PICTORIAL INVENTION IN NETHERLANDISH
MANUSCRIPT ILLUMINATION OF THE LATE MIDDLE AGES:
THE PLAY OF ILLUSION AND MEANING

CORPUS OF ILLUMINATED MANUSCRIPTS

Vol. 16

LOW COUNTRIES SERIES 11

EDITED BY

JAN VAN DER STOCK

ILLUMINARE
CENTRE FOR THE STUDY OF THE ILLUMINATED MANUSCRIPT

SUPPORTED BY THE VAN DER WEYDEN CHAIR
PAUL & DORA JANSSEN
KATHOLIEKE UNIVERSITEIT LEUVEN

JAMES H. MARROW

PICTORIAL INVENTION IN NETHERLANDISH MANUSCRIPT ILLUMINATION OF THE LATE MIDDLE AGES:
THE PLAY OF ILLUSION AND MEANING

ED. BY BRIGITTE DEKEYZER AND JAN VAN DER STOCK

UITGEVERIJ PEETERS

PARIS – LEUVEN – DUDLEY, MA

2005

Library of Congress Cataloging-in-Publication Data

Marrow, James H.
 Pictural invention in Netherlandish manuscript illumination of the Late Middle Ages:
the play of illusion and meaning / James H. Marrow.
 p. cm. -- (Corpus of illuminated manuscripts = Corpus van verluchte handschriften; 16.
Low Countries series; 11)
 Includes bibliographical references and index.
 ISBN 90-429-1615-x (alk. paper)
 1. Illumination of books and manuscripts, Flemish--15th century. 2. Illumination of
books and manuscripts, Flemish-- 16th century. 3. Realism in art--Flanders. I. Title. II.
Corpus of illuminated manuscripts; 16. III. Corpus of illuminated manuscripts. Low
Countries series ; 11.

ND3172.F55M37 2005
745.6'7'0949309024--dc22 2005045853

This publication is the product of an international conference held in Brussels in 2002 on the occasion of the exhibition *Medieval Mastery. Illuminated Art from Charlemagne to Charles the Bold (800-1475)* (Leuven, Stedelijk Museum vander Kelen-Mertens).

© 2005, Peeters Leuven, Bondgenotenlaan 153, Leuven

ISBN 90-429-1615-X
D. 2005/0602/53

TABLE OF CONTENTS

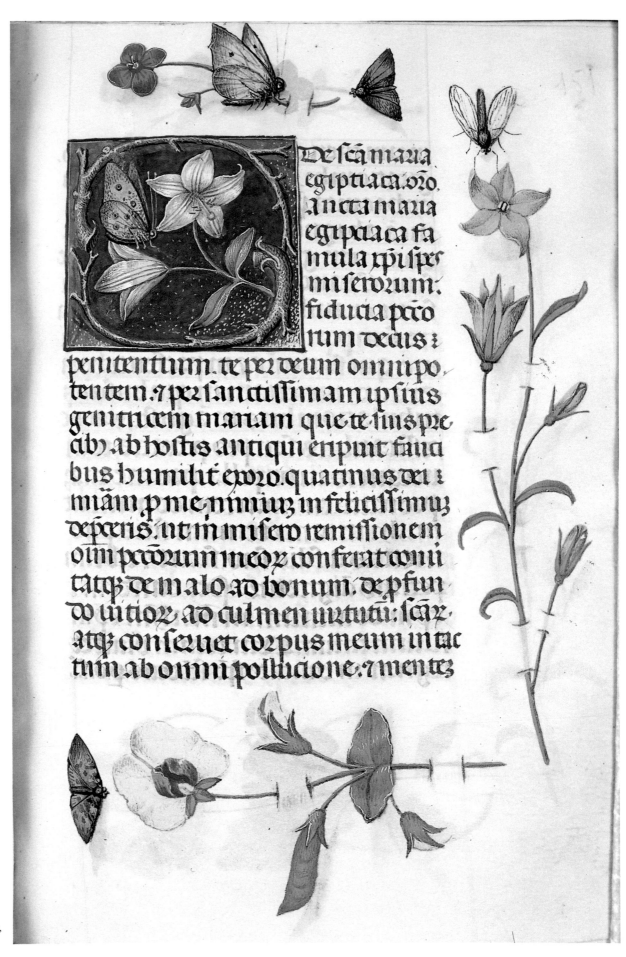

De sca maria
egiptiaca. oro.
Ancta maria
egiptiaca fa
mula xpi spe
mi miserorum.
fiducia peeo
rum decus ꝛ
penitentium. te per deum omnipo
tentem. ꝛ per sanctissimam ipsius
genitricem mariam que te sius pre
abꝛ ab hostis antiqui eripuit faua
bus humili exoro. quatinus dei ꝛ
mam p me nimiuꝛ in felicissimuꝛ
despeenis. ut in misero remissionem
oim peeorum ineoꝛ conferat coni
tatꝓ de malo ad bonum. de pfun
do in tioꝛ ad culmen uirtutu: scaꝛ
atꝓ conseruet corpus meum in tac
tum ab omni pollicione. ꝛ mentꝓ

Decorated text page
from a Book of Hours,
Bruges, ca. 1485. –
Krakow, National
Museum, Czartoryski
Library, Ms. Czart. 3025,
fol. 151.

TABLE OF CONTENTS

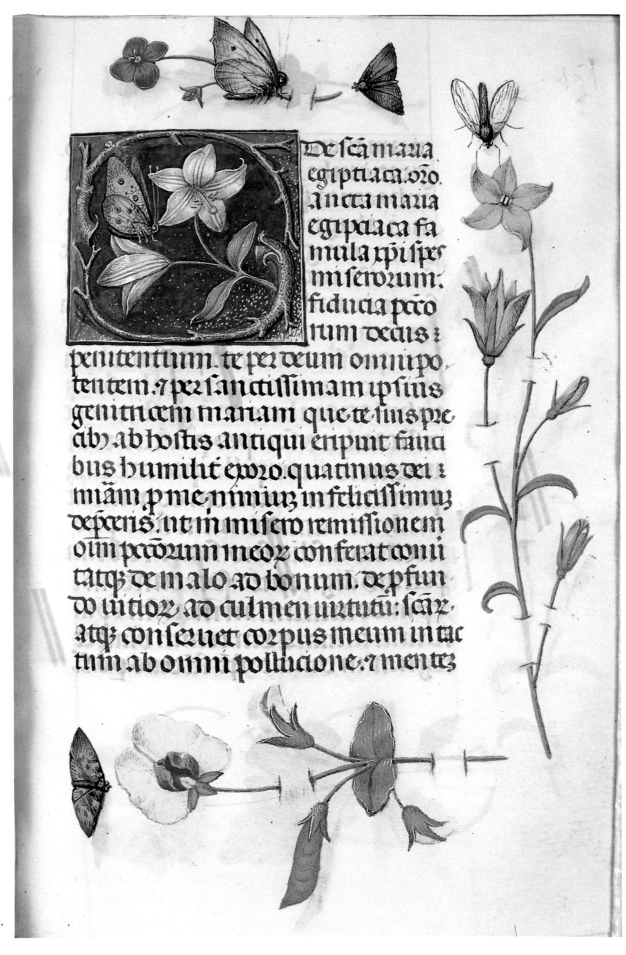

De sca maria
egiptiaca. oro.
Ancta maria
egiptaca fa
mula xpi spes
mi serozum.
fiducia peto
rum decus :
penitentium. te per deum omnipo
tentem. ꝯ per sanctissimam ipsius
genitricem mariam que te insprc
aby ab hostis antiqui eripuit fauci
bus humilit expro. quatmus dei :
miam p me nnniuz in felicissimuz
depcenis. ut in misero remissionem
oim peccatum ineoz conferat comi
tatep de malo ad bonum. depfun
do intior ad culmen uirtutu: scar
atep conseruet corpus meum in tac
tum ab oinni pollucione. ꝯ mentz

PREFACE AND ACKOWLEDGEMENTS

John Walsh, Jr. and Thom Kren commissioned the first version of this essay (then a lecture) more than two decades ago, asking me to justify to an audience composed of both lay people and curatorial staff the place of illustrated manuscripts in museums (as opposed to libraries, where they are most commonly kept and collected), and to demonstrate some of the ways they might engage significant interpretive problems in the history of art. I have had the pleasure of honing the arguments of this paper in the classroom and further developing them in a series of lectures intended primarily for audiences of non-specialists. In revising the most recent version of the lecture for publication, I have expanded some of the material I discuss and, at the request of the editors, I have also added footnote references to literature on select works and problems. I have nonetheless made a concerted effort to preserve the character of this essay as a lecture in the hope that its appeal will not be limited to academic readers. Illuminated manuscripts – particularly those made during the late Middle Ages – were intended to fascinate, delight and charm as well as to instruct; they deserve better than to be relegated to the realm of academic scholarship.

Gregory Clark, Jeffrey Hamburger and Elizabeth Moodey kindly read drafts of this study and offered useful suggestions for improvement; Jonathan Alexander contributed insightful observations on the miniatures I discuss from the *Boussu Hours* (ills. 51-54). For help in acquiring photographs for reproduction, I am grateful to Albert Derolez, Urs Düggelin, Andreas Fingernagel, Thom Kren, and Will Noel, and for grants to defray some of their costs as well as in support of research travel, I acknowledge the invaluable support of the Spears Research Fund of the Department of Art and Archaeology at Princeton University. I thank Bert Cardon, Jan Van der Stock and Brigitte Dekeyzer for their kind invitation to publish this essay in the Corpus of Illuminated Manuscripts, Low Countries Series, edited by *Illuminare – Centre for the Study of Illuminated Manuscripts* of the Katholieke Universiteit Leuven, Brigitte Dekeyzer for invaluable suggestions for improvements of the wording and structure of the text, as well as for superintending corrections of the proofs, and Uitgeverij Peeters for their care in all aspects of its production.

I dedicate this publication, with love, to my children.

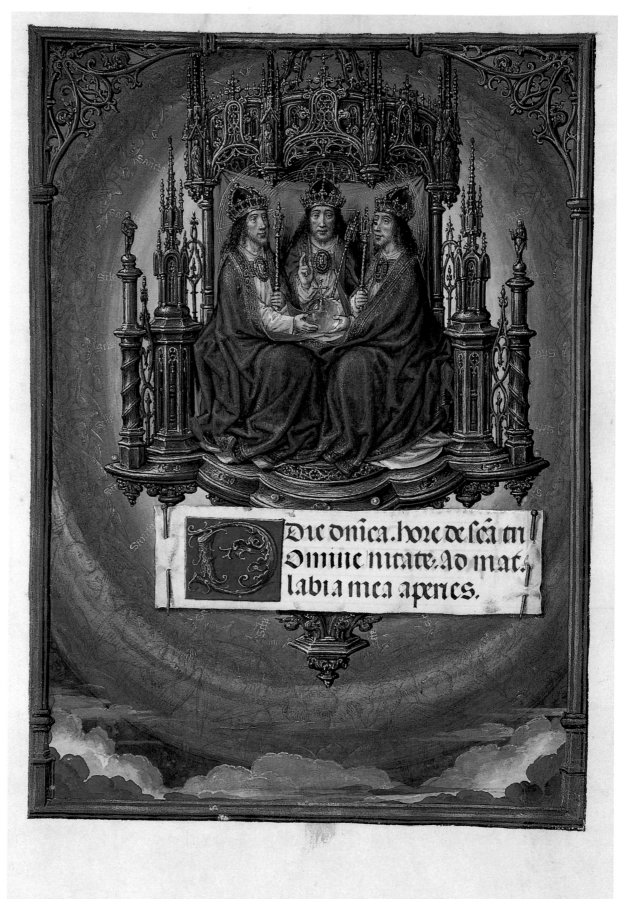

Master of James IV of
Scotland, *The Trinity*,
miniature from the
Spinola Hours, Bruges
and Ghent, ca. 1510-1520.
– Los Angeles, The J.
Paul Getty Museum, Ms.
Ludwig IX 18, fol. 100v.

PICTORIAL INVENTION IN NETHERLANDISH MANUSCRIPT ILLUMINATION OF THE LATE MIDDLE AGES

INTRODUCTION

The final phase of medieval manuscript illumination was, ironically, the richest and the most aesthetically exuberant in the history of the hand-painted book. During the 150 years extending from about 1390 to 1540, the production of illuminated manuscripts expanded dramatically in several mutually beneficial directions. This was a result of continuing and renewed patronage at both older and newly established court centres, which set the fashion for a growing class of enthusiasts new to both patronage and wealth, and entrepreneurial initiatives by members of the book trade. The expanded commerce in illuminated manuscripts accelerated the pace of artistic interchange among different centres and craftsmen, and it also stimulated the emergence of new varieties of book types, styles and manufacture. Quality, quantity and diversity all increased. There was a proliferation of centres where finely crafted, handwritten books might be ordered and a corresponding growth in regional styles of illumination. Individuals commissioned or purchased many new types of illustrated books, and some more traditional manuscript types, such as Books of Hours, enjoyed unprecedented popularity.

The period also brackets the introduction of printing with moveable type, around 1450, and overlaps with that of many of the early experiments in introducing mechanically produced illustrations into handwritten and printed books. The makers of manuscripts were keenly aware of developments in the upstart medium, and they rose to the challenge: the first century of printmaking also saw the creation of ever more flamboyant manuscript designs. Faced with the existence of an alternative market of printed books, some of the leading producers of illuminated manuscripts pulled out all the stops, fashioning books of a richness and complexity that were beyond the capabilities of even the most ambitious printers. They targeted the discerning elite of the luxury book market, and for more than three quarters of a century, they succeeded in carving out an important niche before finally being overcome by a combination of changing economic, social and aesthetic conditions that included growing technical and aesthetic sophistication on the part of printers.

For much of this period, the duchy of Burgundy held political, economic and social sway in Europe.[1] This pre-eminence and the cachet of the accomplished artistic styles cultivated in the leading cities of the duchy created a new locus of cultural and aesthetic interest in the North. Burgundian cultural influence expanded because of its prominence in European trade, including a lively commerce in art; the growing appeal of Flemish art to foreign artists during their early training and *Wanderjahre* (the period young artists spent travelling in order to widen their artistic perspectives); and, by the end of the century, the incorporation of the Burgundian duchy itself into the pan-European context of the Holy Roman Empire. Manuscript illumination played an important part in the efflorescence of Burgundian culture, and many of the most opulent and pictorially sophisticated illuminated manuscripts made during the fifteenth and the sixteenth centuries were produced in the southern Netherlands.

Despite the historical importance and the aesthetic complexity of late Flemish illuminated manuscripts, there have been few analyses of either the scope or the implications of many of their most innovative features. To be sure, studies of late Flemish manuscript illumination abound, ranging from facsimiles and investigations of individual books to considerations of major developments in the tradition. New surveys of Flemish manuscript illumination have appeared in

recent years, and major exhibitions have been devoted both to extensive and chronologically restricted groups of works.[2] While this outpouring of scholarly and popular publications has contributed to greater knowledge of the material, it has yet to do justice to some of the most striking achievements of leading Netherlandish manuscript illuminators, including many of the developments that I consider central to the character of their works, to the novelty of their creations, and to the appeal of their works both in their own time and to present-day viewers. Part of the problem lies in a persistent fragmentation of manuscript studies along disciplinary and methodological lines and an accompanying disinclination to pursue new topics of inquiry or expansive approaches to old questions.

In this essay, I focus on two topics in the study of Netherlandish manuscript illumination of the fifteenth and the sixteenth centuries that seem to me to be inadequately defined and under-appreciated: the play of illusionism in some of the most ambitious works of the period and the novel ways in which that play structures and conveys meaning. My aim is to consider the design of medieval books, especially the constituent elements of book production, and, equally important, the ways in which different elements of book design complement one another. I propose to look beyond the individual components of medieval manuscript production (such as format, layout, script, decoration and illustration) to wider considerations of the ways in which these parts evolved in parallel and sometimes in complex interaction with one another. Such a viewpoint is essential for the period that concerns us, for as I shall argue, some of the most prominent features of illuminated manuscripts produced in northern Europe during the late Middle Ages are the imaginative ways in which their creators reinterpreted the relationships among the components of the book, at once changing their visual dynamics and enabling them to inflect and convey meaning in fresh ways.

I hope also to offer an alternative to the specialized studies that predominate in scholarship on medieval manuscript illumination – for example, those by paleographers and practitioners of many of the subcategories of art historical research (decorative, iconographic, stylistic). For all that they have contributed to knowledge, they have frequently obscured access to larger questions of the journeys that the designers and makers of medieval books travelled as they proceeded along complex paths of trial, error and mutual discovery. To treat such subjects, I think it is essential to take an unusually broad view of the manuscript book, to consider different components of the book in tandem, to look at the "longue durée" as well as particular moments, and to retain a willingness to appreciate overarching patterns of development alongside of particular ones.

I focus in this essay primarily on works of southern Netherlandish manuscript illumination, although I shall occasionally refer to works from neighbouring artistic traditions wherever they offer useful and striking examples of the kinds of explorations with which I am concerned. This expansive geographical viewpoint provides an important reminder that developments in book design in the southern Netherlands also belong to wider currents of the evolution of the medium in northern Europe. Most of the experiments and inventions that I will consider appear in lavishly decorated and illustrated manuscripts. Comparable instances of the play of illusion and meaning can sometimes also be found in more modestly conceived works, but they seem to have blossomed within the pages of manuscripts produced for particularly demanding and discriminating patrons. These factors, among others, help to explain why Netherlandish illumination was so highly prized by collectors both within and outside the Low Countries, and why it continued to prosper well into the sixteenth century.

ILLUSIONISM AND BOOK DESIGN IN NETHERLANDISH MANUSCRIPT ILLUMINATION

Netherlandish manuscript illumination of the late fifteenth and the early sixteenth century is best known and justly famed for its accomplished pictorial illusionism. Two pages from Prayer Books of the period, the first from a Book of Hours in the Pierpont Morgan Library attributed to Simon Marmion (ill. 1)[3] and the second in the *Grimani Breviary* (ill. 2),[4] exemplify many of the kinds of illusionistic mastery for which Flemish illuminators were widely admired. They demonstrate their interest and achievements in rendering exquisitely detailed and panoramic landscape vistas, monumental figures, and extraordinarily lifelike still-life objects, including flowers and fruits, precious objects and jewels, and animals, such as the peacock who ambles about on the simulated projecting shelf beneath a miniature from the *Grimani Breviary*, seemingly having overturned a glass or a vase of flowers in the process (ill. 2).[5]

The inspiration for this loving concern with the appearances and objects of the world in northern European art derives from the tradition of Flemish panel painting, which was inaugurated in the early fifteenth century by artists such as Jan van Eyck. Van Eyck's masterpiece, the *Ghent Altarpiece* (ills. 3-4), dedicated in 1432, already shows many of the characteristics

we most admire in Flemish manuscript illumination of the following century, including a command of panoramic and detailed landscape vistas, monumental figures, meticulously rendered flora (ill. 5) and precious objects (ill. 6). No wonder, then, that as early as around 1440-1450, Flemish illuminators began to take inspiration from and sometimes copy Van Eyck's paintings. Examples include a full-page miniature of the 'Holy Face' from a Book of Hours in the Pierpont Morgan Library (ill. 7)[6] that is based on a painted exemplar by Jan van Eyck known to us through numerous copies and replicas on panel, many of which, like the version in Bruges (ill. 8),[7] repeat Jan's signature. Another example, a full-page miniature of the 'Virgin and Child' in half length by Simon Bening, painted around 1540 (ill. 9),[8] demonstrates that Van Eyck's art was still an important source of pictorial inspiration for Flemish illuminators nearly a full century after his activity: the miniature derives, albeit indirectly, from the upper portion of the figure of the Virgin in Jan's panel in Berlin of the *Madonna in a Church* (ill. 10), probably painted in the 1430s.[9] Indeed, many Flemish illuminators of this period were so deeply influenced by the traditions of Flemish panel

painting that, just as Bening did in his work (ill. 9), they set their miniatures into simulated wooden or gilt frameworks, complete with what appears to be carved tracery at the corners.

Considering the mastery of pictorial illusionism by Flemish illuminators and their seemingly effortless command of all aspects of the visual world, it is no wonder that this facet of their art has dominated our appreciation of the manuscripts they painted. But these miniature paintings occur in hand-produced books, and we deprive ourselves of a sense of the full aesthetic qualities of these objects if we look only at their illustrations. In fact, the aesthetic exuberance and visual creativity to which I referred are manifested not only in illustrations, but in all aspects of the design of the manuscript book at this time, including format, layout, script and decoration.

My first goal in the following pages, therefore, will be to call attention to innovations in some of these other areas of book design.[10] We may begin with a striking example of a creative experiment in format, in which the designer of a *chansonnier*, or collection of love songs, thought to truly equate form and content by giving the book the shape of a heart (ill. 11).[11] The

ILL. 1.
Simon Marmion, *Visitation*, miniature from a Book of Hours, Valenciennes, ca. 1480. – New York, The Pierpont Morgan Library, Ms. M. 6, fol. 29.

ILL. 2.
St Andrew, miniature from the *Grimani Breviary*, Ghent and Bruges, ca. 1515-1520. – Venice, Biblioteca nazionale Marciana, Ms. lat. I, 99, fol. 470v.

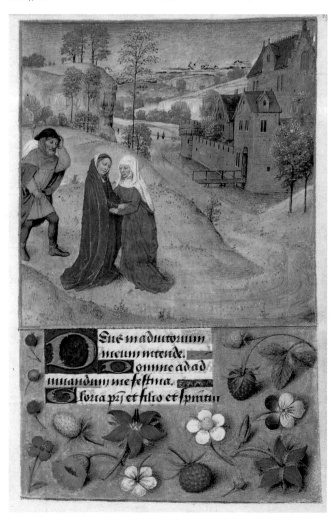

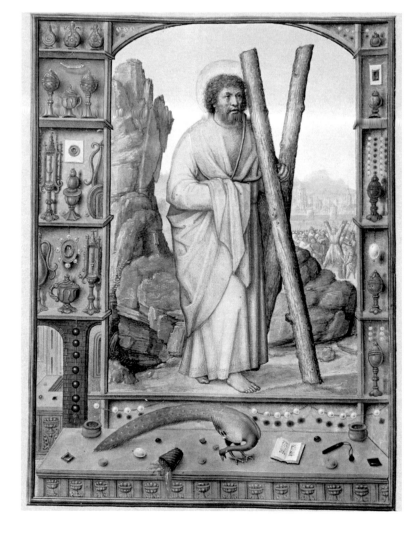

ILL. 3.
Jan van Eyck, *The Ghent Altarpiece*, closed position, oil on panel, 1432. – Ghent, St Bavon.

ILL. 4.
Jan van Eyck, *The Ghent Altarpiece*, open position, oil on panel, 1432. – Ghent, St Bavon.

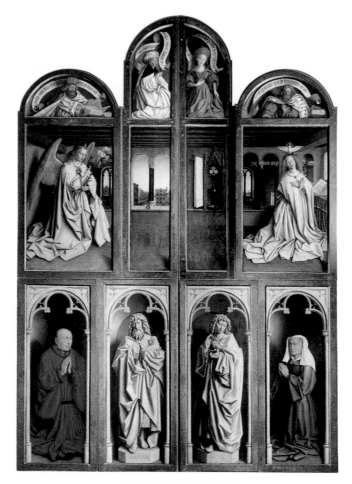

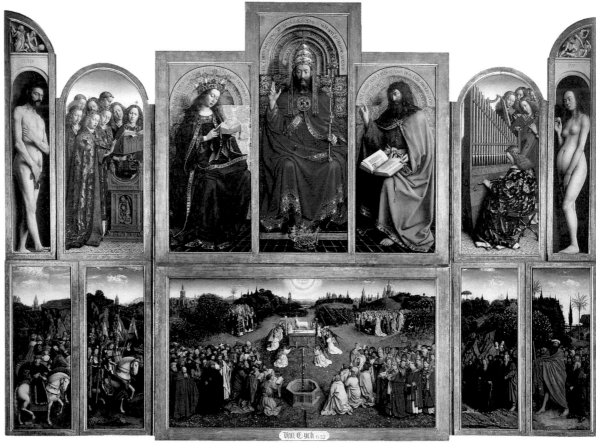

Chansonnier of Jean de Montchenu appears to have been made in Savoy around 1480, but other examples of heart-shaped books are known from Picardy and the Low Countries, and demonstrate that the format was used for devotional books as well as secular ones. In addition to a heart-shaped Book of Hours from Amiens,[12] we have further testimony to the vogue for such books in two portraits of young men shown holding heart-shaped books by the Master of the View of Sainte Gudule, who was active in Brussels in the 1470s and eighties, as can be exemplified by the panel in London, National Gallery (ill. 12).[13]

Some other experiments in page layout and design are no less striking. Most illustrated Books of Hours inter-mix groups of consecutive text pages with occasional miniatures, so placed as to mark major divisions between texts or text segments. One clever French book designer or illuminator, however, came up with a novel means of mitigating the alternation of groups of text pages with occasional miniatures. His solution was to represent the illustrations as roundels set into the middle of the page (ill. 13),[14] and to cut equivalently sized and located holes in all of the text pages (ill. 14); as a result, even when reading the text pages, the viewer could simultaneously see both the preceding miniature and the one upcoming.[15] This novel design creates what one might consider a 'perpetually illustrated' Book of Hours, rather than one in which the miniatures appear only at intervals between groups of text pages.

Even the type of formal script – one of the most conservative elements in the history of the medieval book – was altered and elaborated in this period. Throughout the high Middle Ages the heavy, incised Gothic script dominated the hierarchy of formal script types. With its angular compartmentalization of individual letters and its regular horizontal compression, it creates the profile of a rectangular block that reiterates the rectangular shape of the book and its pages (ill. 15).[16] Although Gothic script did not die out in the fifteenth century, Flemish scribes of the period adopted a new formal script type in which the letter forms are rounded and current, rather than angled and incised; where they lean to the right, in accord with the path of our eyes when we read; and where the monotonous regularity of formal Gothic is further alleviated by letters that extend above and below the lines and sometimes terminate in curved and flourished forms (ill. 16).[17] Termed *lettre bourguignonne* or Burgundian *bastarda*, the new script was initially used particularly for deluxe works made for members of the court. As can be seen in the many Flemish manuscripts written in Burgundian *bastarda* (ills. 17-18), this script is more varied, elegant, and lighter in its appearance than Gothic. And once introduced and accepted, the new formal script was itself elaborated. In the *Vienna Hours of Mary of Burgundy*, the scribe, Nicolas Spierinc, extends some of the letters at the top and bottom of the page into complex calligraphic flourishes, known as cadelles, which bring

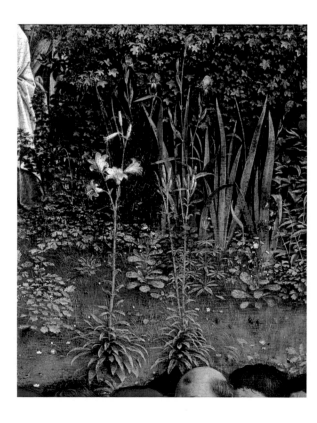

ILL. 5
Jan van Eyck, *The Ghent Altarpiece*, detail: Flora of the central panel. – Ghent, St Bavon.

ILL. 6.
Jan van Eyck, *The Ghent Altarpiece*, detail: the Jewel on God the Father's robe. – Ghent, St Bavon.

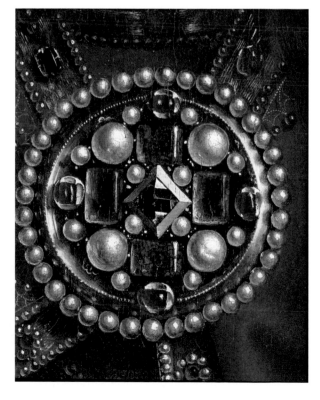

ILL. 7.
Head of Christ (Vera Icon), miniature from a Book of Hours, Bruges, ca. 1440-1450. – New York, The Pierpont Morgan Library, Ms. M. 421, fol. 13v.

ILL. 8.
Copy of a lost original by Jan van Eyck, *Face of Christ (Vera Icon)*, original dated 1440. – Bruges, Groeningemuseum, Inv. no. 0.206.

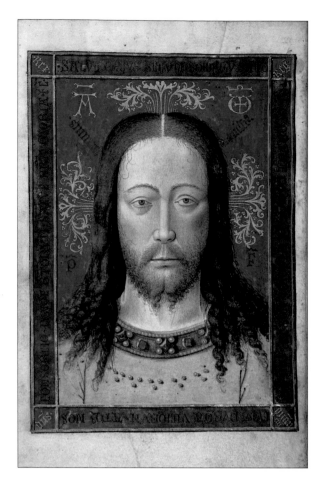

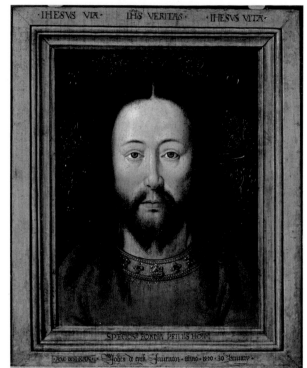

ILL. 9.
Simon Bening, *Madonna and Child*, miniature from a Rosarium Prayer Book, Bruges, ca. 1540. – Dublin, Chester Beatty Beatty Library, Ms. W. 99, fol. 44v.

ILL. 10
Jan van Eyck, *Madonna in a Church*, oil on panel, Bruges, ca. 1435. – Berlin, Staatliche Museen zu Berlin, Preussischer Kulturbesitz, Gemäldegalerie, Inv. no. 525c.

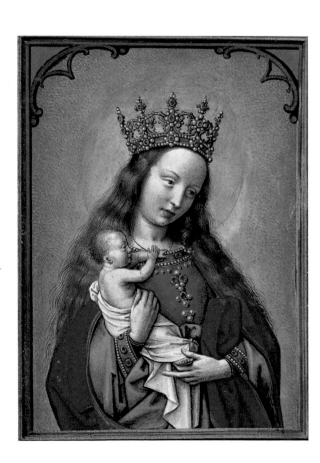

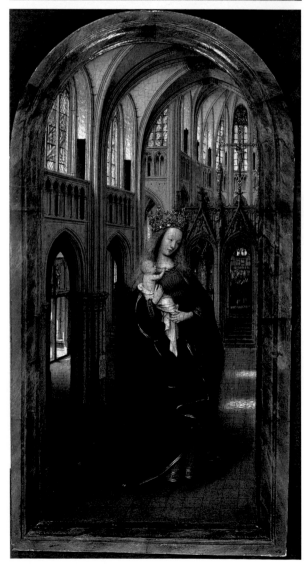

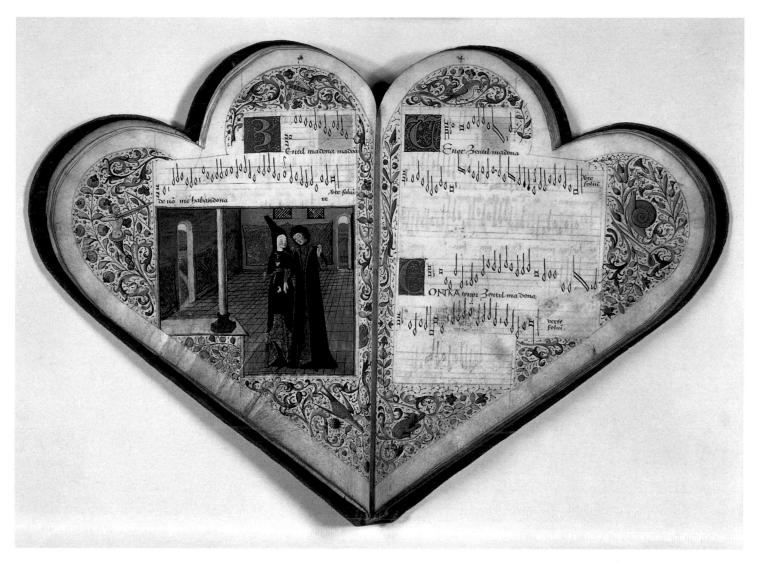

ILL. 11.
Lovers (miniature) and song pages from the *Chansonnier of Jean de Montchenu*, Savoy, ca. 1480. – Paris, Bibliothèque nationale de France, Ms. Rothschild 2973, fols. 3v-4.

to mind something of the quality of a trill or fanfare (ill. 17).[18] Similarly, in a copy of Christine de Pizan's *Epitre d'Othéa* in the James A. de Rothschild Collection at Waddesdon Manor, the initials which flank the miniature and principal text are elaborated into 'pen-doodles', including faces (ill. 18).[19] In both these works (ills. 17-18), the script begins to function as a kind of marginal decoration. Indeed, some Flemish scribes produced what one might term a full-page 'doodle initial' (ill. 19),[20] which functions simultaneously as script and as decoration. Considering both its painted physiognomic forms and its full-page format, the initial can even be read as a kind of illustration.

Border decoration underwent the greatest elaboration during the late Middle Ages, fundamentally changing the structural dynamics of the page and enlarging its fields of visual and pictorial interest. In seemingly endless permutations and combinations, decorative elements in the margins variously anchor the text to the plane of the page, articulate relationships among its parts, add colour and sparkle to leaves

and openings, mitigate the rectangular structure of the text block and pages by introducing complex forms of differing character, and provide a platform for new forms and genres of pictorial embellishment.[21] The process began in the thirteenth century, when letter forms were first extended down (ill. 20)[22] and then across and around the text (ill. 21).[23] These decorative elements gradually assumed organic and especially botanical shapes and proceeded to support flora, fauna and real and imaginary figures (ill. 22);[24] this led to more elaborate frameworks that incorporate leaf forms of diverse character. The formal vocabulary is extensive, ranging from bold structural and foliate elements (ill. 23)[25] to delicate and lacy forms, which enclose the text in a shimmering, halo of light (ill. 24).[26]

By the first half of the fifteenth century, Netherlandish artists began to represent large-scale figures and floral forms in manuscript borders. Noteworthy examples include a Dutch Book of Hours of about 1415, where the opening leaf of the Seven Penitential

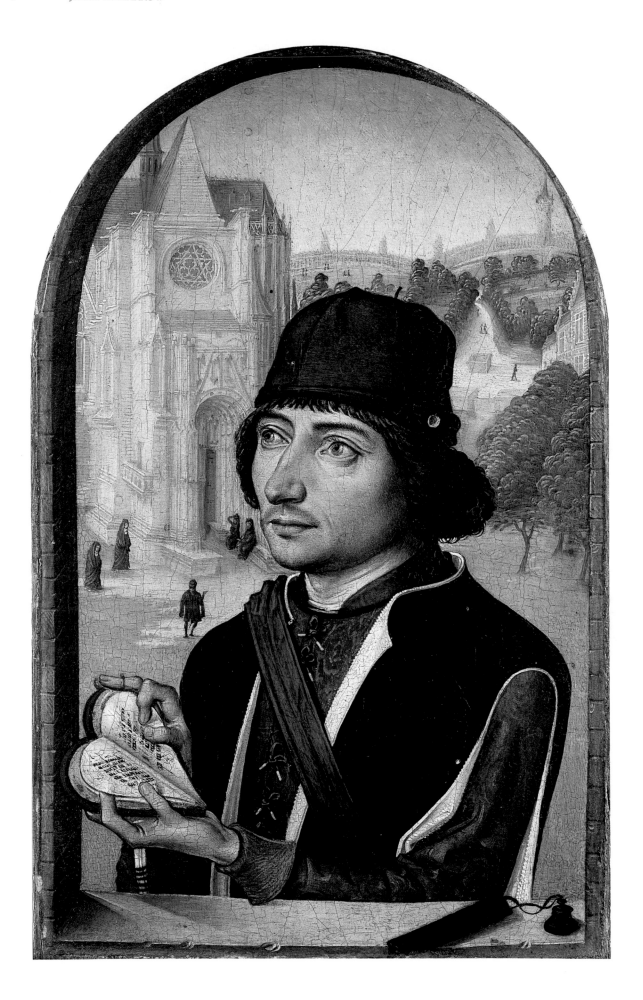

ILL. **12.**
Master of the View of
Sainte Gudule,
*Portrait of a Young Man
with a Heart-Shaped
Book*, Brussels,
ca. 1480. – London,
National Gallery,
Inv. no. NG 2612.

Psalms and Litany is surrounded by a fanciful border of facing and addorsed dragons whose tails terminate in foliate tendrils (ill. 25),[27] and a Book of Hours by the Master of Guillebert de Mets, made in Flanders probably around 1450, where oversized foliage in the margins encloses figures who supplement the action of the central miniature (ill. 26).[28] This being the century of Van Eyck, illuminators increasingly turned to real objects from the visual world when composing their borders. Around 1440, the Dutch illuminator known as the Master of Catherine of Cleves decorated some of the margins of the *Hours of Catherine of Cleves* with an array of mundane objects that include mussels and crabs (ill. 27) and even pretzels (ill. 28).[29]

Flemish illuminators of the late fifteenth century specialized particularly in border designs composed of meticulously crafted representations of fruits and flowers (ill. 29),[30] and they also frequently indulged their illusionistic virtuosity by the conceit of painting insects on the page, as if attracted by the flora (ill. 30).[31] Profiting from that same virtuosity, some illuminators, apparently in reaction to the anomalous appearance of floral forms seemingly floating in the void of the white margins of the vellum, anchored them to the page by painting simulated incisions

ILL. 16.
Text page (Burgundian *bastarda*) from Honoré Bonet, *L'arbre des batailles*, Southern Netherlands, 1461. – Brussels, Royal Library of Belgium, Ms. 9079, fol. 163v.

ILL. 17.
Text page from the *Hours of Mary of Burgundy*, Ghent, written by Nicolas Spierinc, ca. 1470-1475. – Vienna, Österreichische Nationalbibliothek, Ms. 1857, fol. 65.

ILL. 18.
Hector imploring Priam to allow him to go into Battle, miniature from Christine de Pizan, *Epitre d'Othéa*, Lille, publishing house of Jean Miélot, ca. 1455 (miniatures added in Ghent [?], ca. 1485). – Waddesdon Manor, James A. de Rothschild Collection, Ms. 8, fol. 49.

ILL. 19.
Decorated "M" from a "Minute", or draft copy, of the *Speculum humanae salvationis* prepared in 1449 for Philip the Good by Jean Miélot of Lille. – Brussels, Royal Library of Belgium, Ms. 9249-9250, fol. 1.

ILL. 20.
St Juliana at Prayer in letter "A", miniature from the *Vita sanctae Julianae*, Mosan, ca. 1261-1280. – Paris, Bibliothèque de l'Arsenal, Ms. 945, fol. 24.

ILL. 21.
Decorated text page from a Book of Hours of Liège Use, Liège, ca. 1300-1310. – Baltimore, Walters Art Museum, Ms. W. 37, fol. 19.

ILL. 22.
Facing decorated text pages from a Book of Hours, Thérouanne, ca. 1300. – Baltimore, Walters Art Museum, Ms. W. 90, fol. 74v-75.

ILL. 23.
Decorated text page
from a Book of Hours,
Flanders or Artois,
ca. 1400-1410. –
Baltimore, Walters Art
Museum, Ms. W. 215,
fol. 20.

ILL. 24.
Text page from the
De Lévis Hours, Paris,
ca. 1415-1420. – New
Haven, Yale University,
Beinecke Library,
Ms. 400, fol. 102.

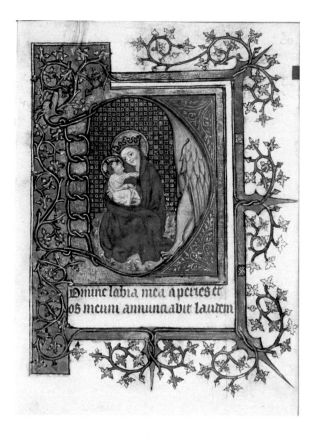

ILL. 25.
Master of the Morgan
Infancy Cycle, *David
playing the Psaltery and
border of Dragons*,
miniature from a Book
of Hours, Delft, ca.
1415-1420. – New York,
The Pierpont Morgan
Library, Ms. M. 866,
fol. 79.

ILL. 26.
Master of Guillebert
de Mets, *St George*,
miniature from a Book
of Hours, Southern
Netherlands (possibly
Tournai), ca. 1450. –
Los Angeles, The
J. Paul Getty Museum,
Ms. 2, fol. 18v.

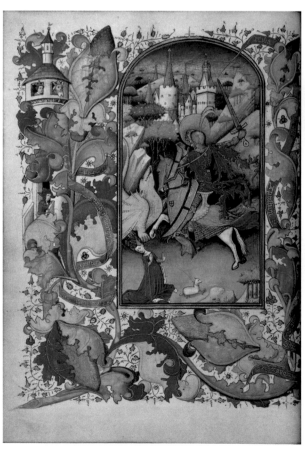

in the vellum so that the flowers seem to be interwoven into the page itself (ill. 31).[32]

But the more common way that Flemish illuminators reconciled their naturalistically rendered border objects with the field of the vellum was to frame the text or miniatures with coloured or gilt panels, against which the painted objects seem to stand in relief, particularly as they are usually represented casting shadows onto the panels (ill. 32).[33] This effect was also amplified and played with, as in the *Grimani Breviary* (ill. 33),[34] where an illuminator paints a magnificent, large dragonfly in the lower margin and shows his transparent wings as if extending over the text, decorated panels, and parts of the lower margin. He thereby adds a third 'layer' of depth and illusion to the page, above those of the gilt panel and the still-life objects it supports. This exceptional display of painterly virtuosity clearly honours St Luke – the patron saint of painters – shown working at his easel on the same page. While the column miniature at the upper left corner of the leaf refers in a conventional

manner to Luke's status as an exemplary painter and functions implicitly as an emblem of its maker's profession, the bravura depiction of the dragonfly at the opposite corner of the same leaf provides another kind of paradigm of the craft of painting, this one informed by tropes of artistic prowess known from Antiquity which celebrated artists' abilities to create illusion, including that of objects on or in front of paintings, and thereby fool the eye.[35]

Another Flemish illuminator accorded the floral forms in his border so much importance (ill. 34)[36] that two of the flowers extend beyond the panel at the right side of the page to cut across and impede part of our view into a miniature of the evangelist, St Mark, in his study. This violation of the normally sacrosanct division between the hieratically more important miniature and the usually subordinate decorated border seems to have attracted the attention of St Mark's lion, who turns his head and stares in apparent disapproval at the intrusion into his space.

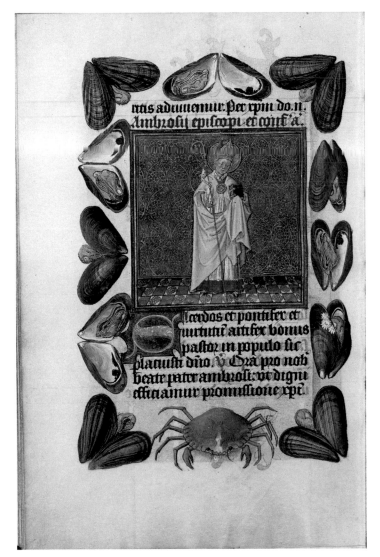

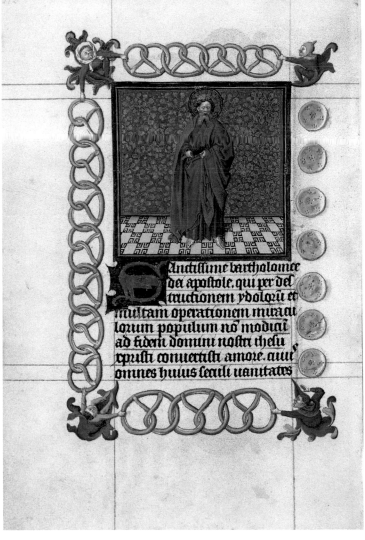

Another variety of border decoration favoured by Netherlandish illuminators consists of simulated textiles or fabric patterns. Examples include a page in the *Hours of Catherine of Cleves*, where the Cleves Master transforms a painted fabric border into a simulated processional banner that displays both miniature and text (ill. 35);[37] and one in the *Voustre Demeure Hours* in Madrid (ill. 36),[38] where the text on one page is framed by what appears to be four strips of fabric or paper in a textile pattern. Because such borders, including that in the Cleves Hours, sometimes compromised the status of the text, leaving it seemingly disembodied on an illusionistically painted field, it occurred to some illuminators to suggest that the text was part of an independent sheet of parchment superimposed on the framing textile (ill. 37).[39]

No stronger evidence could be found to underscore the growing importance of border decoration in Netherlandish manuscript illumination than the fact that the borders eventually became coequal in specie with the painted miniatures. In a miniature page from a Book of Hours illustrated around 1440 by the Master of the Privileges of Ghent (ill. 38), bits of the tessellated or checkerboard pattern of the

background of the miniature seem to have migrated into the border, where they appear in the leafy foliage in the left margin;[40] in another page from the same manuscript (ill. 39) the migration is complete, for the entire border is composed of the decorative patterning traditionally found in the backgrounds of miniatures.[41]

The real triumph of border illumination in this respect came when it matched the pictorial illusionism of the painted illustrations. In a miniature page from the *Turin-Milan Hours* (ill. 40),[42] a manuscript attributed by many scholars to Jan van Eyck himself and dated by some of these to the first quarter of the fifteenth century, the pictorial character of the main miniature is matched by that of the historiated initial and the frieze-like area beneath the text. The initial and the depiction beneath the text, moreover, are conceived of as part of an illusionistic whole. From God the Father in the initial, the dove of the Holy Spirit descends along the Father's line of sight to the figures of John the Baptist and Christ below, who are shown in the foreground of a panoramic and minutely detailed landscape that seems to extend back without interruption to a distant, hazy horizon.

ILL. 29.
Decorated text page from a Book of Hours, Bruges, ca. 1520-1530. – Rouen, Bibliothèque Municipale, Ms. 3028 (Leber Ms. 142), fol. 70.

ILL. 30.
Decorated text page from a Book of Hours, Bruges, ca. 1520-1530. – Rouen, Bibliothèque Municipale, Ms. 3028 (Leber Ms. 142), fol. 100.

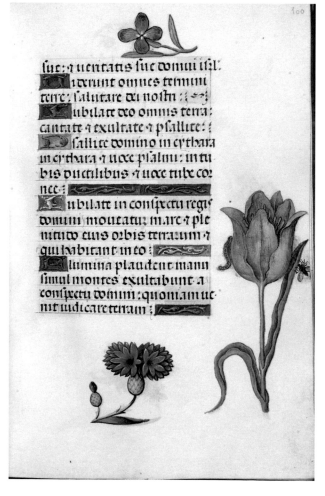

By the latter part of the fifteenth century, many Flemish illuminators commonly treated the border areas as pictorial zones fully encircling the traditional central miniatures. Whether those areas continue the central picture space (ill. 41) or are independent of it (ill. 42), they usually contain complimentary subject matter, as can be seen in two leaves from a Book of Hours in Rouen painted around 1520 by Simon Bening.[43] In the first example (ill. 41), the landscape setting of the 'Visitation' extends on all sides beyond the framed central area. The scope of the vista and the lyrical mood are enhanced by the lovely scene in the lower margin, where a deer stoops to drink from a peaceful stream or pond while two swans glide silently by. In the second (ill. 42), the marginal scene represents the attempt of Mary and Joseph to find room at the inn, an event that precedes the 'Nativity', which is the subject of the central miniature.[44] Such fully historiated borders obliterated the traditional distinction between pictorial miniatures, which were conceived as scenes that project behind the plane of the page into depth, and the decorated margins, which

earlier had adhered to the flat plane of the vellum; now painted margins and miniatures alike were conceived of as spatial projections back into depth behind the plane of the page.

Historiated or pictorial borders also appear on text pages (ill. 43),[45] but the result can be aesthetically jarring, especially in instances like that in a Flemish Book of Hours of the late fifteenth century (ill. 44),[46] where the text seems simply to float in the midst of an otherwise internally coherent spatial representation. Illuminators tackled this problem of page and text design with gusto and imagination, some suggesting, as in a page from the *Spinola Hours* (ill. 45),[47] that the text was pinned to the page, and others, as in the *Voustre Demeure Hours* (ill. 46),[48] that the otherwise disembodied text block was suspended by ropes from the framework of the pictorial border. More than mere page design may be at stake in these works, for some medieval thinkers were concerned with the relative importance of the evidence of hearing and seeing – or of word (text) and images – in understanding man's place in the

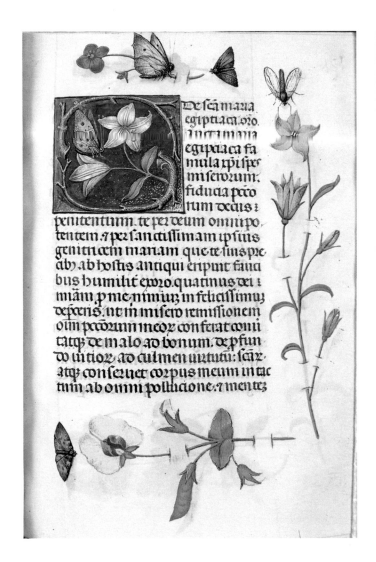

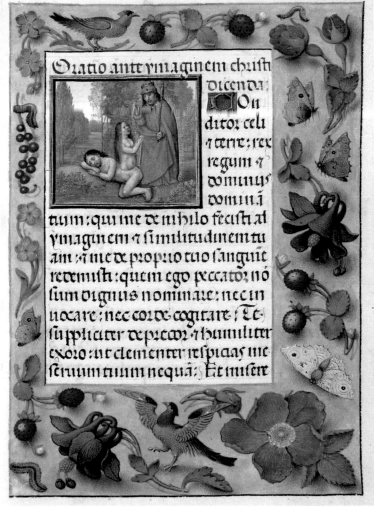

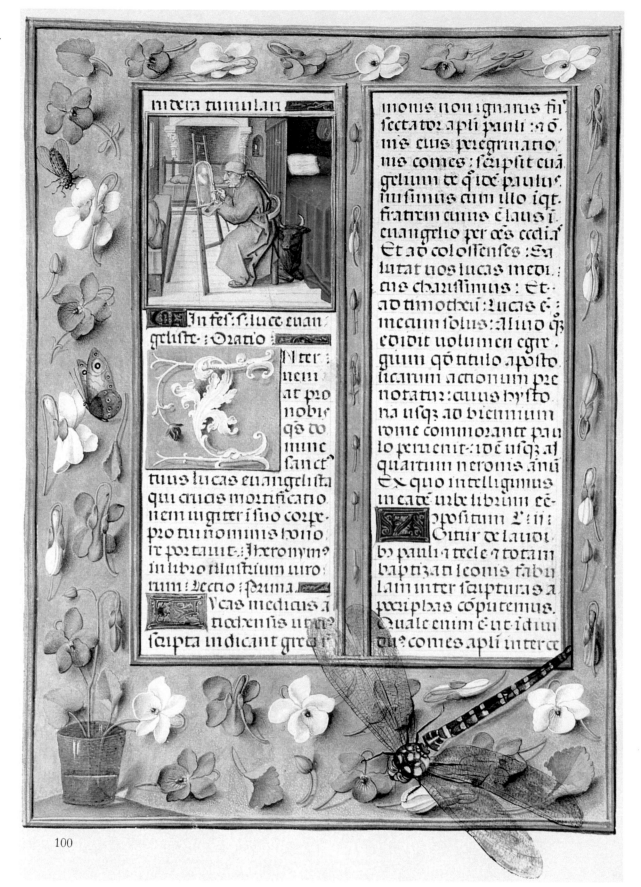

100

ILL. 34.
St Mark, miniature from a Book of Hours, Bruges, ca. 1490. – St Benedict (Oregon), Mount Angel Abbey, Ms. 67, fol. 40.

ILL. 35.
St Jerome, miniature from the *Hours of Catherine of Cleves*, Utrecht, ca. 1440. – New York, The Pierpont Morgan Library, Ms. M. 917, p. 242.

actions of things.[49] One wonders if, in thus subordinating written texts to pictures, depictions where words are shown tethered or otherwise 'affixed' to images do not comment in a witty manner on the growing authority accorded to sight over hearing in the late Middle Ages.

A particularly striking solution to analogous questions of page design and attendant meaning occurs in a miniature in the *Grimani Breviary*, where the illuminator of a page showing the 'Building of the Tower of Babel' (ill. 47)[50] thought to place the text on what I take to be the first billboards in history, or at least in art. Is this striking manner of juxtaposing image and text an instance of mere aesthetic play, or might it not also allude wittily to the purport of the event depicted? In the context of an illustration of the event that, after all, ended the universality of verbal communication, I am inclined to consider that this conspicuous display of texts on fictive structures located within the picture space of the 'Building of the Tower of Babel' comments ironically on the meaning of this story.

PICTORIAL MEANING IN ILLUSIONISTIC MANUSCRIPT ILLUMINATION

Having explored some innovations in manuscript design during the fifteenth and sixteenth centuries, including format, layout, script, and decoration, we have come back full-circle to illusion, which is one of the principal topics of this essay. This is an appropriate juncture, therefore, to turn to the second subject I wish to stress, which is *meaning*, particularly as it is conveyed and elaborated in manuscripts by illusionistic painting.[51] Not that the expression and the conveyance of meaning in manuscripts are restricted only to painting, for as we may briefly recall, the preparation of a book of love songs in the shape of a heart (ill. 11) gave direct visual form to the meaning of its contents. Nonetheless, it is chiefly through illusionistically painted objects and images that Netherlandish

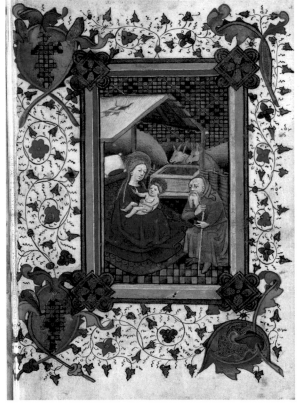

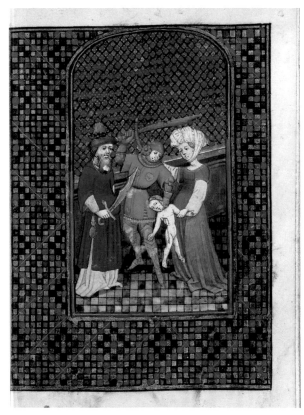

ILL. 40.
"Hand G" (Jan van Eyck?), *The Birth of St John the Baptist* (large miniature) and *Baptism of Christ* (historiated initial and bas-de-page), leaf from the *Turin-Milan Hours*, The Hague (?), ca. 1425. – Turin, Museo Civico d'Arte Antica, Inv. no. 47, fol. 93v.

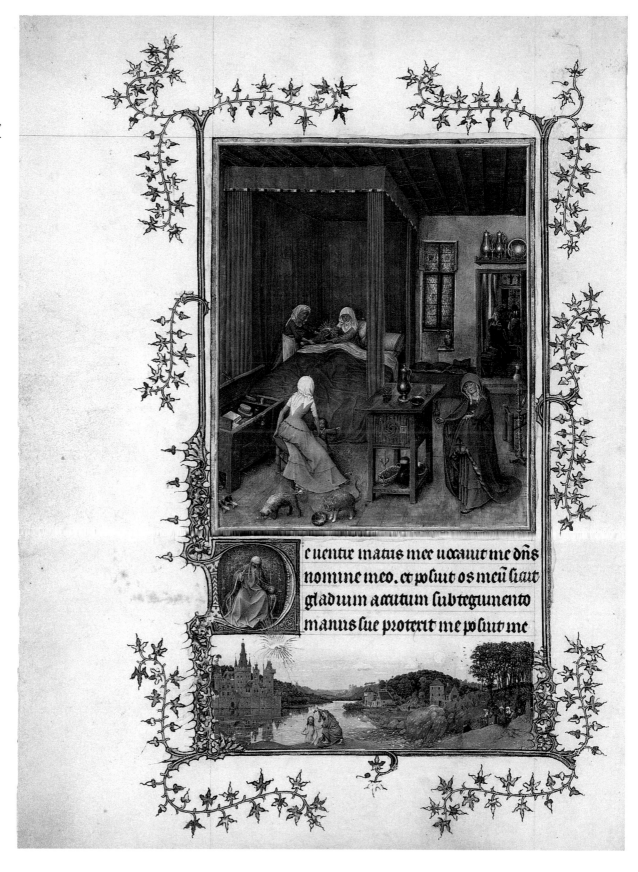

illuminators of the late Middle Ages elaborated upon the meaning of their books and their contents.

Painted borders provided a ready sphere in which to interpret or comment on the subjects of miniatures and text.[52] A page in the *Hours of Catherine of Cleves* with a miniature of St Sebastian (ill. 48) has a border of bows, crossbows, arrows and quivers, because Sebastian was shot with arrows by bowmen and was the patron saint of most archer's guilds.[53] In a Flemish Book of Hours of the late fifteenth century, a page with a prayer to St James the Great has a margin of cockle shells (termed *coquilles Saint-Jacques* in French), which were the emblem of this pilgrim saint as well as reminders of the most famous of medieval pilgrimages, that to Santiago da Compostela in Spain (ill. 49).[54] In this example, the choice of gold and silver for the shells evokes associations with the precious objects appropriate for the cults of sanctified figures and objects, a subject we will presently consider more fully.

Images pertaining to death were particularly suited to visual explication and amplification through marginal representations. Depictions of skulls and bones are especially common (ill. 50),[55] their large

scale in relation to the central miniature bringing them close to the viewer and impressing upon him one purpose of the page or scene, which is to function as a *Memento Mori*, or a reminder of death.

Similarly striking are a group of paired miniatures and facing painted borders in the Passion cycle of the *Boussu Hours* in the Arsenal Library in Paris.[56] The full-page miniature of 'Christ Praying in the Garden of Gethsemane' faces a page whose border contains representations of drops of water and blood (ills. 51-52). The explanation for this unusual marginal depiction is to be found in the Gospel of St Luke, where the account of Christ's prayer in the Garden informs us that, "And being in an agony, he prayed the longer, And his sweat became as drops of blood trickling down upon the ground" (Luke 22: 43-44).[57] The drops of water or sweat also look like teardrops, which links the imagery on this page with that on the next opening that we shall consider and also suggests another facet of Christ's suffering during his agony in the Garden of Gethsemane.

Equally arresting, both as an image and as an elaboration of the meaning and moment of the event

ILL. 41.
Simon Bening, *Visitation*, miniature from a Book of Hours, Bruges, ca. 1520-1530. – Rouen, Bibliothèque Municipale, Ms. 3028 (Leber 142), fol. 105.

ILL. 42.
Simon Bening, *Nativity* (central miniature) and *Mary and Joseph refused Admittance to the Inn at Bethlehem* (historiated border), miniature from a Book of Hours, Bruges, ca. 1520-1530. – Rouen, Bibliothèque Municipale, Ms. 3028 (Leber 142), fol. 116.

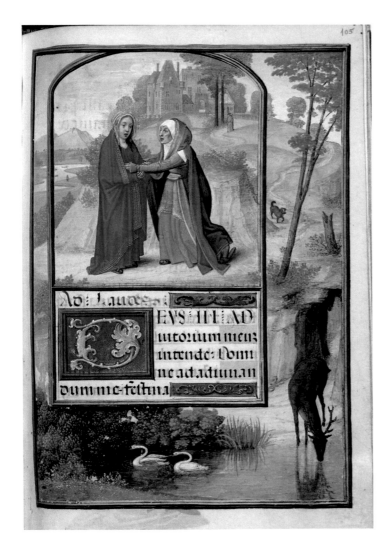

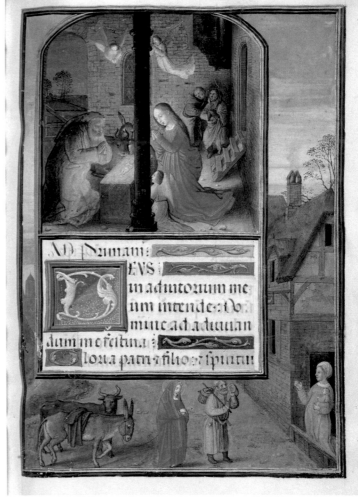

represented in the facing, full-page miniature of the 'Carrying of the Cross' in the same manuscript, is a border that contains crying eyes (ills. 53-54). Once again the explanation for the border comes from the Gospel of St Luke, where in the account of the Carrying of the Cross the evangelist quotes Christ's comment to the women who follow him, "Daughters of Jerusalem, weep not over me but weep for yourselves, and for your children" (Luke 23: 28). Precisely because of their strangeness, such marginal depictions capture our attention and draw us more fully into the subjects and meanings of the full-page illustrations with which they are paired. At the same time, the juxtaposed orders of imagery found on these leaves also have other functions. In addition to visualizing details of St Luke's text, the teardrops suggested and portrayed on both these openings serve as cues to spectators' reaction to these images of the Passion, modelling examples for them of tearful empathy.

I will consider only one more example of a painted border that qualifies or amplifies the religious meaning of a traditional miniature in this manner. On a page from a Book of Hours in the Huntington Library (ill. 55),[58] an illustration of the 'Crucifixion' is situated within a marginal representation of a fountain. The juxtaposition evokes the metaphorical association, commonplace at this time, which likened the crucified Christ to the Fountain of Life or Pity. A panel painting of the period by Jean Bellegambe that depicts 'Christ on the Cross' emerging from an elaborate fountain in which souls desirous of salvation bathe themselves (ill. 56)[59] provides an example of this association. While Bellegambe's painting is purely allegorical in its subject matter, the miniature seems to have it both ways, representing both the historical Crucifixion on Calvary, complete with witnesses, *and* alluding to the allegorical meaning of the event.

The illusionistically painted borders of Netherlandish manuscripts can also express meaning in more general although no less important terms. Borders of peacock feathers frame some religious miniatures, and not only because they are visually opulent objects, but also because, during the Middle Ages, the peacock was considered the bird of paradise, an identification based in part on the belief that its flesh was not subject to decay.[60] In the opening that commences the

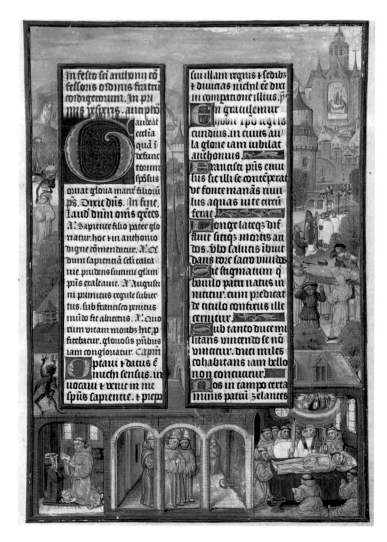

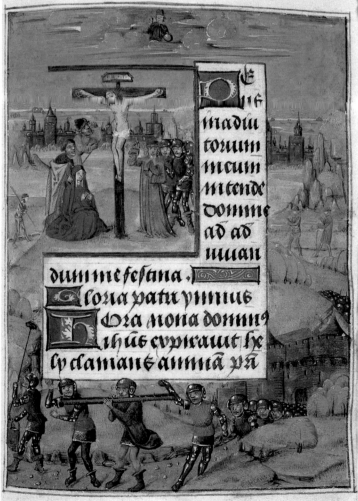

ILL. 45.
Master of James IV of
Scotland, *The Trinity*,
miniature from the
Spinola Hours, Bruges
and Ghent, ca. 1510-
1520. – Los Angeles,
The J. Paul Getty
Museum, Ms. Ludwig
IX 18, fol. 100v.

ILL. 46.
Vienna Master of
Mary of Burgundy,
Scenes from the Passion,
miniature from the
Voustre Demeure Hours,
Ghent, ca. 1475-1480. –
Madrid, Bibliotheca
Nacional, Ms. Vit. 25-
5, fol. 14.

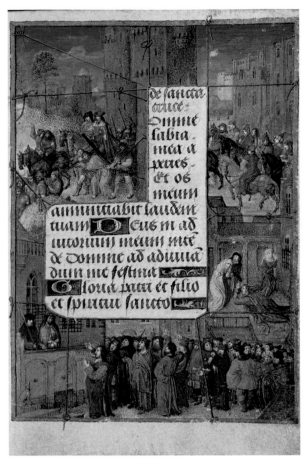

Office of the Virgin in the *Hours of Engelbert of Nassau* (ill. 57),[61] the peacock feathers in the margins presumably allude to Mary's importance, and that of the event of the Annunciation, in man's attempt to regain paradise; in a miniature in the *Breviary of Eleanor of Portugal* (ill. 58),[62] the motif is an appropriate framework for a miniature of the 'Ascension of Christ' by virtue of the fact that Christ's flesh, like that of the peacock, does not decay.

A similarly generalized but no less sacred meaning probably accounts for the popularity of pages in which miniatures of religious figures and events are surrounded by panel borders studded with jewels,[63] as can be exemplified in leaves from the *Hours of Engelbert of Nassau* (ill. 59)[64] and the *Da Costa Hours* (ill. 60).[65] The appearance of such borders comes at the end of a tradition, continuous throughout the Middle Ages, in which jewels were represented on such objects as crosses (ill. 61)[66] and reliquaries (ill. 62),[67] which enclose sanctified materials; pulpits from which God's word was preached (ill. 63);[68] and the bindings of books containing sacred texts (ill. 64).[69] The many jewelled frames about miniatures in Flemish Prayer Books and liturgical manuscripts (ills. 59-60) summon up and perpetuate this longstanding tradition of fittingly glorifying the sacred, while also underscoring the character of these books as luxury objects.

Special attention should be paid to other kinds of border motifs or representations that allude to the purpose and function of the books in which they are found. In the *Book of Hours of Catherine of Cleves*, one of the miniature pages is bordered by a marginal representation of the owner's own rosary (ill. 65),[70] an identification implied by the representation of Catherine's initials on the pouch in the lower margin. This representation of the duchess's prayer beads is self-referential in a double sense, alluding both to Catherine's ownership of the book and to its function as one of the vehicles of her prayer.

Another fascinating example occurs in the *Vienna Hours of Mary of Burgundy* (ill. 66).[71] The full-page miniature that faces the first prayer in this manuscript portrays the owner of the book reading in an oratory that offers a view through an open window of a divine encounter. There, attended by four youthful angels, the Virgin Mary is adored by a kneeling female figure who is accompanied by three other women and a man who kneels swinging a censer. The depiction pointedly contrasts margin and centre, things close and things distant, the profane and the sacred, the here-and-now and the timeless, worldly reality and heavenly vision.

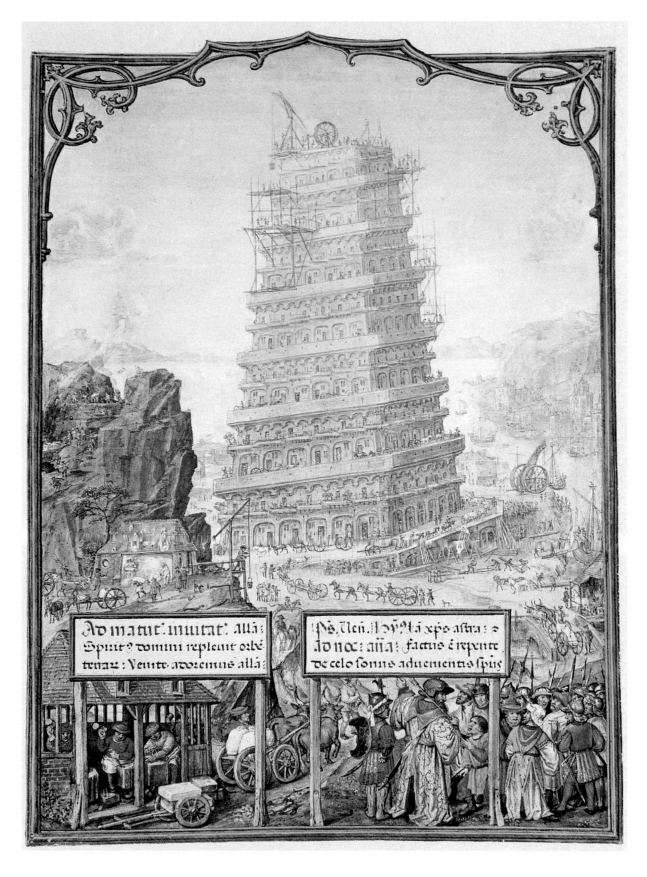

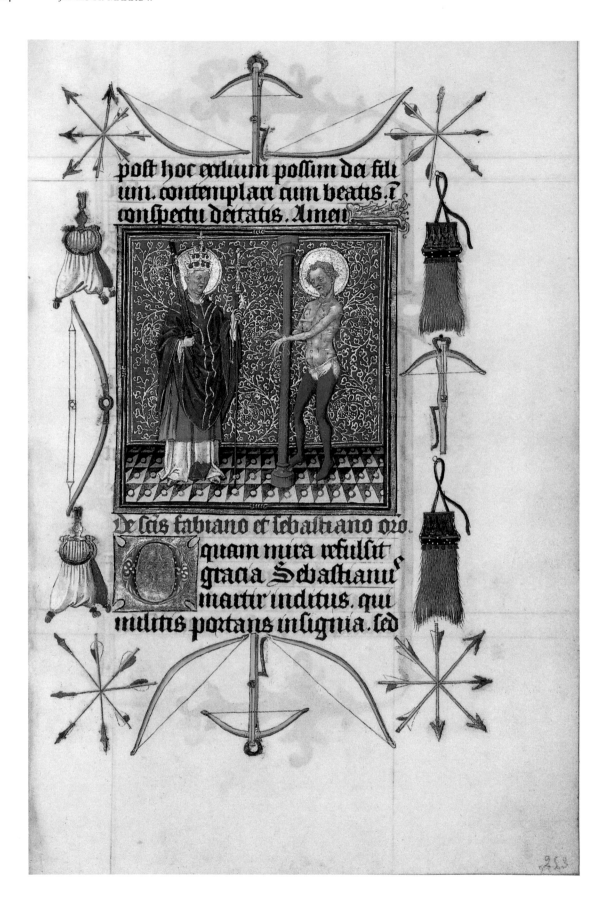

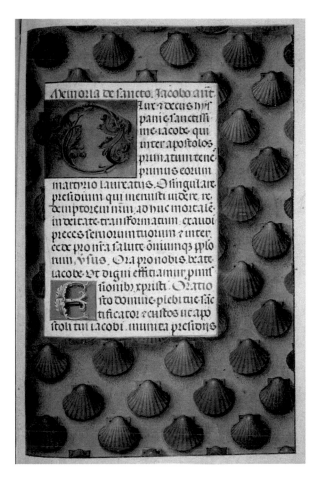

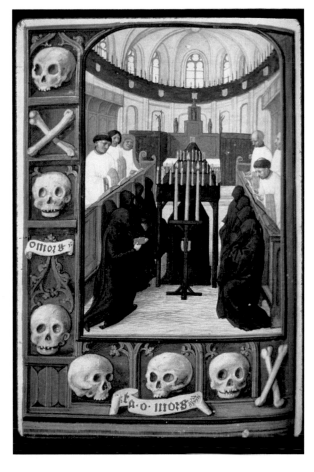

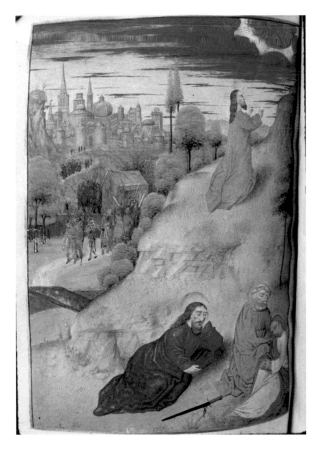

ILL. 53.
Master of Antoine
Rolin, *Carrying of the
Cross*, miniature from
the *Boussu Hours*,
Hainaut, ca. 1490. –
Paris, Bibliothèque de
l'Arsenal, Ms. 1185,
fol. 195v.

ILL. 54.
Master of Antoine
Rolin, *Christ Nailed to
the Cross and border of
crying eyes*, miniature
from the *Boussu Hours*,
Hainaut, ca. 1490. –
Paris, Bibliothèque de
l'Arsenal, Ms. 1185,
fol. 196.

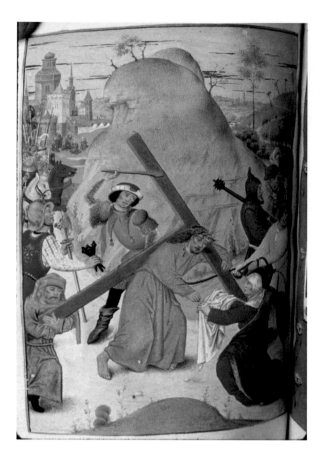

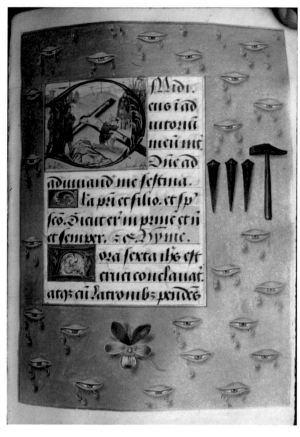

ILL. 55.
*Crucifixion with
fountain border*,
miniature from a Book
of Hours, Bruges,
ca. 1490-1500. –
San Marino, The
Huntington Library,
Ms. HM 1174, fol. 14v.

ILL. 56.
Jean Bellegambe,
Fountain of Life (or
Pity), oil on panel,
ca. 1525. – Lille, Musée
des Beaux-Arts,
Inv. no. P 832.

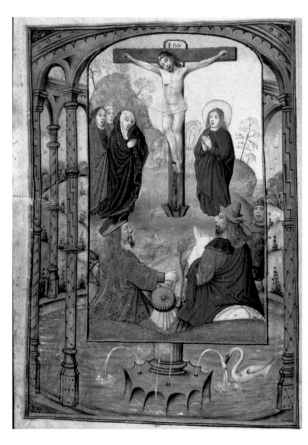

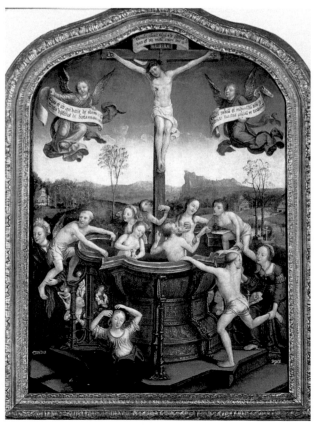

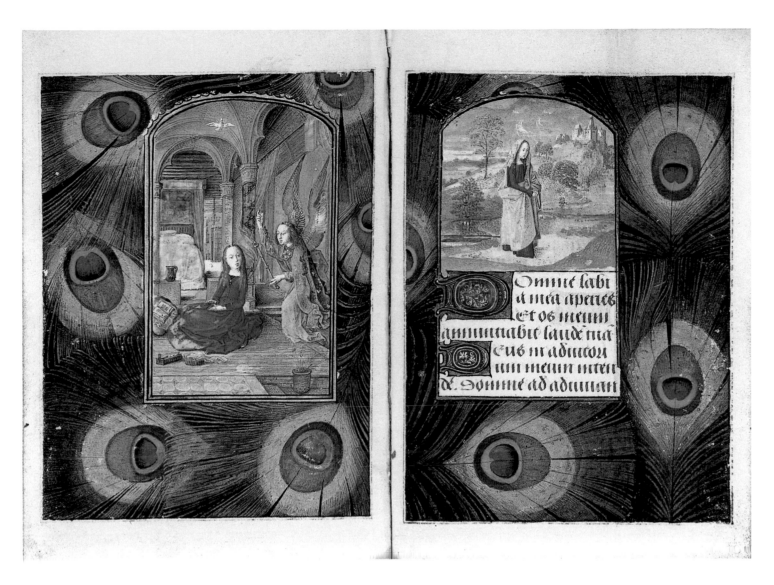

Once again the image is concertedly self-referential and comments insightfully on the function of the type of book in which it is found. That is, in this book made for a Burgundian princess, the owner is shown reading the very book, and then, on the same page, the artist visualizes the desired aim or purpose of her prayerful devotion by showing either herself or ones dear to her imaginatively transported to the sacred realm and granted an audience, as it were, by the Virgin and Child.

The play on this kind of meaning is elaborated still further in a subsequent miniature in the book that shows 'Christ being nailed to the Cross' (fig. 67). This scene is represented through an aperture analogous to that in the earlier miniature, here displaying in its framing lower portion what we understand as the owner's prayer beads and open manuscript, but, somewhat surprisingly, without any sign of the duchess herself. As if reacting to her absence, some of the figures in the miniature look out of the picture space toward the open window, seemingly in admoni-

tion. Taken together, the two miniatures address the topic of the duchess's devotion, although in different ways, commenting both on its necessity and its desired results. They function as ingenious though subtle reminders to the owner to use the very book prepared for her by one of the most accomplished Flemish illuminators of the day.

ILLUSIONISM AND THE WORLD OF THE BEHOLDER: THE SPECULUM CONSCIENCIE

In the final section of this essay, I want to discuss an extraordinary illustration that plays on the inherent duality of illusionism as apparent fact and fiction in order to project the meaning of an image into the world and the consciousness of its beholder, thereby linking the realms of past and present, art and life. This occurs in an opening from the *Book of Hours of Joanna of Castile*, painted probably in Bruges around 1500, which pairs a miniature of the 'Fall of Man' at

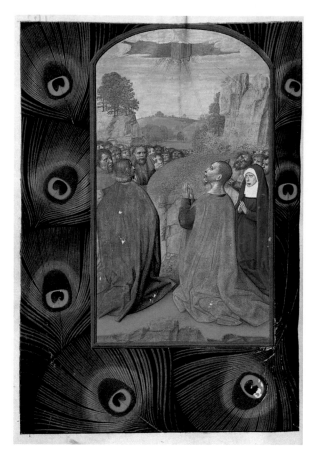

the left with a representation of a skull in a mirror – labelled *Speculum consciencie* – on the facing page (ills. 68-69).[72] We begin with the right-hand page (ill. 69), which functions as an overt *Memento Mori*,[73] and consider it in relation to much wider traditions of imagery of death in Northern European art. Although unusual in important details, the imagery of the page is not entirely novel, for dead figures and skulls are frequently represented with mirrors in late medieval art. Examples in which dead figures look into mirrors include a marginal detail from a French Psalter of around 1300, where a corpse regards himself in a mirror held in his hands (ill. 70),[74] and a half-page miniature from a fifteenth-century French Book of Hours, where a decayed corpse kneels on a tombstone, his hands joined in prayer as he regards himself in a mirror suspended from a tree (ill. 71).[75] The figures in both seem to contemplate their state as corpses.

In two other representations, a woodcut and a panel painting, we encounter living figures who hold or behold mirrors that reflect skulls (ills. 72-73). At the left side of the woodcut illustration (ill. 72),[76] a German work of around 1500, a demon points to a blank mirror that he holds up before two young lovers, and encourages them to behold themselves in the mirror and to enjoy the pleasures of youth. At the right side of the woodcut, in contrast, an angel points to a mirror that reflects the image of a skull and urges

a group of three older figures to prepare themselves for God and his heavenly reward. This moralizing representation thus illustrates the antithesis between sinful and prudent self-reflection. In the masterful *Portrait of the Artist Hans Burgkmair and his Wife Anna*, dated 1529 (ill. 73),[77] we see Burgkmair's wife holding a mirror that shows a reflection of two skulls. The mirror frame is inscribed "O Death" at the top, and "Recognize yourself" on the forward edge, but such labels are essentially redundant in this visually direct and affecting *Memento Mori*; here the dispirited expressions of the couple, directed out of the image toward us, simultaneously bespeak a profound melancholy in their awareness of their own mortality and seem to beseech our sympathy.

The miniature from the *Hours of Johanna of Castile* (ill. 69) departs in one important way from the entire known tradition of representations of dead figures or skulls in mirrors, that is, in its *focus*. For unlike all other representations of death or skulls with mirrors, in which we invariably see *other* figures, whether dead or alive, regarding themselves, here there are no 'other' figures: the mirror with its image of a skull directly faces the viewer, who is made to see and imagine him- or herself as dead. Indeed, in this regard, the miniature departs from the entire tradition of representations of death in medieval art, even those without mirrors. In depictions of such subjects as the 'Dance of Death' (ill. 74),[78] the 'Triumph of Death' (ill. 75),[79] or the '*Ars Moriendi*' (ill. 76),[80] to name only three common pictorial treatments of death during the period, it is invariably *other* figures whom we see dying or claimed by death. The distinction also holds for the many other representations of skulls in the art of this period, all of which can also be understood as references to the death of others (ill. 77).[81] In sum, prior to the image in the *Hours of Johanna of Castile* death was always presented to viewers through the intermediary of the experiences of others; in this miniature, in contrast, the image and the experience are turned on the viewer.

Here we are led back, once again, to Jan van Eyck, the pioneer in the exploration of pictorial illusionism in Flemish art, who offers us his own visual commentary on its purpose and meaning. In Van Eyck's *Arnolfini Portrait* in London (ill. 78), the mirror on the back wall of the painting reflects not only the reverse side of the figures and objects visible in the painting, but also figures and objects that must be understood as occupying the real space in front of his image.[82] For Van Eyck, as for the painter of the skull in a mirror in the *Hours of Johanna of Castile*, the work of art makes overt claims even upon that which is external to it – that is, on the world of the spectator, including the beholder himself.

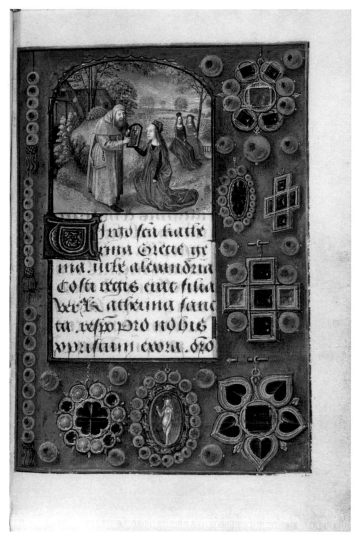

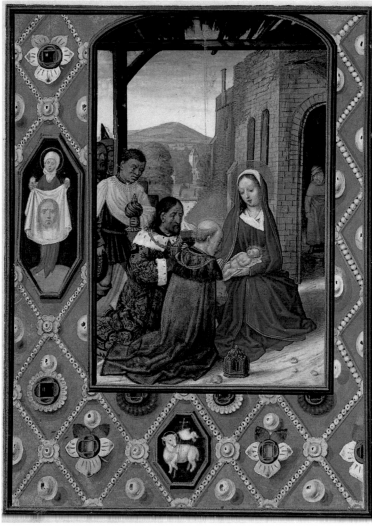

ILL. 59.
Vienna Master of
Mary of Burgundy,
*St Catherine receives a
Picture of the Virgin
and Child from a
Hermit*, miniature
from the *Hours of
Engelbert of Nassau*,
Ghent, ca. 1475-1485. –
Oxford, Bodleian
Library, Ms. Douce
219-220, fol. 40.

ILL. 60.
Simon Bening,
Adoration of the Magi,
miniature from the
Da Costa Hours,
Bruges, ca. 1515. –
New York, The
Pierpont Morgan
Library, Ms. M. 399,
fol. 162v.

All of this is intended, of course, to compel the viewer to see himself in the context of a real relationship with what the artist represents; that is, to proclaim that the viewer must engage pictorial subject matter on terms that implicate him experientially – not just cognitively – in the world of the image and its meaning. And it is against this background of a new concern with the viewer's presence in relation to the image and its corollaries in terms of the bond that it implies between the two, that we may understand the achievement of the depiction in the *Hours of Johanna of Castile* (ill. 69). On the right-hand page the focus and meaning of a *Memento Mori* are directed in front of the image, to simultaneously refer to and incorporate the viewer. Indeed, the visual and moral implications of this image are complemented and expanded by the page that faces the mirrored skull (ill. 68). There, the Fall of Man is seen though an archway, as if occurring at some distance from us, but the Expulsion from Paradise is represented in such a way as to suggest that the first parents are ushered forward from within the image into the real world of the beholder. Together, the two images visually state that Adam and Eve were banished into *our world*, and that the result of the fall from grace is that those of us who inhabit the fallen world must confront our own mortality. The facing leaves also trace a significant temporal span, linking the distant past of the Fall to the present-day world, into which Adam and Eve appear to be banished, and then compelling the viewer to contemplate his own future state as deceased. This double image can thus be understood as a kind of pictorial essay on the enlarged field of activity of illusionistic art, its enhanced capacities to link past, present and future, and its new possibilities for refocusing meaning directly upon the viewer.

And that message, concerned not only with *what* art means, but also *how* it means, is conveyed with special force and insight in illuminated manuscripts, whether by the way that Flemish miniaturists exploit the relationships between figures represented in marginal zones and those depicted in the miniatures to draw us in new ways into the experience of their images, or by the fact that, as hand-held objects

ILL. 61.
Jeweled Processional Cross (the "Bernward Cross"), Hildesheim, before 1022. – Hildesheim, Dom- und Diozesanmuseum, Inv. no. DS L 109.

ILL. 62
Statue-Reliquary of Sainte Foy, France, late 10th and 11th centuries, with Gothic and later additions. – Conques, Abbey Church of Sainte Foy, Treasury.

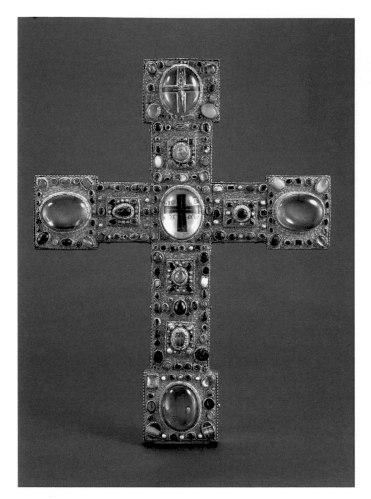

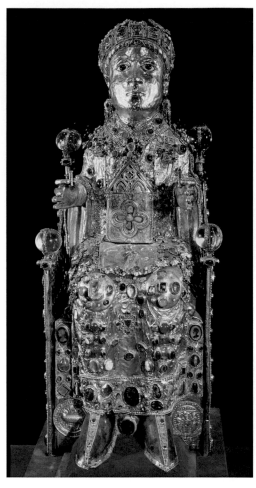

ILL. 63.
Golden Pulpit of Henry II, West German, ca. 1002-1014. – Aachen, Palatine Chapel.

ILL. 64.
Cover of the Berthold Missal, Swabia, ca. 1215-1517. – New York, The Pierpont Morgan Library, Ms. M. 710.

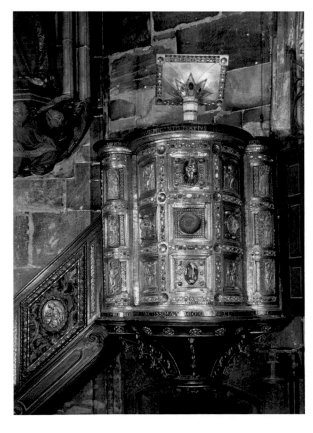

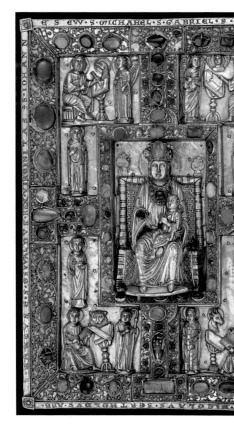

ILL. 65.
Adoration of the Magi with Rosary border, miniature from the *Hours of Catherine of Cleves*, Utrecht, ca. 1440. – New York, The Pierpont Morgan Library, Ms. M. 917, p. 237.

,ILL. 66.
Vienna Master of
Mary of Burgundy,
*Mary of Burgundy (?)
at Prayer*, miniature
from the *Vienna Hours
of Mary of Burgundy*,
Ghent and Bruges,
ca. 1470-1475. –
Vienna, Österreichis-
ches Nationalbiblio-
thek, Ms. 1857, fol. 14v.

ILL. 67.
Vienna Master of
Mary of Burgundy,
*Christ Nailed to the
Cross*, miniature from
the *Vienna Hours of
Mary of Burgundy*,
Ghent and Bruges,
ca. 1470-1475. – Vienna,
Österreichisches
Nationalbibliothek,
Ms. 1857, fol. 43v.

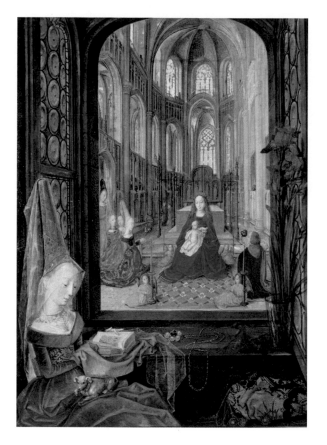

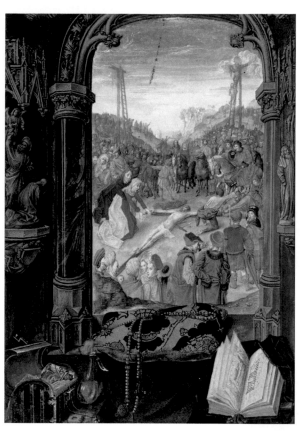

ILL. 68.
Master of the David
Scenes in the
Grimani Breviary,
The Fall of Man,
miniature from the
*Hours of Johanna
of Castile*, Bruges or
Ghent, between 1496
and 1506. – London,
The British Library,
Add. Ms. 18852,
fol. 14v.

ILL. 69.
Master of the David
Scenes in the
Grimani Breviary,
*Skull Reflected in a
Mirror* (the *Speculum
consciencie*),
miniature from the
*Hours of Johanna of
Castile*, Bruges or
Ghent, between 1496
and 1506. – London,
The British Library,
Add. Ms. 18852, fol.
15.

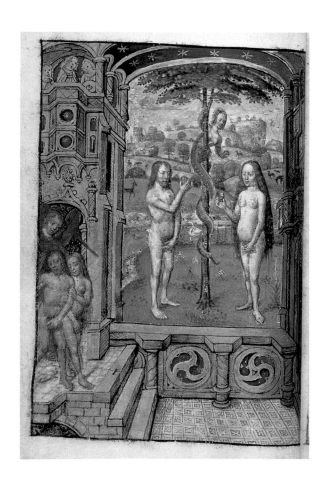

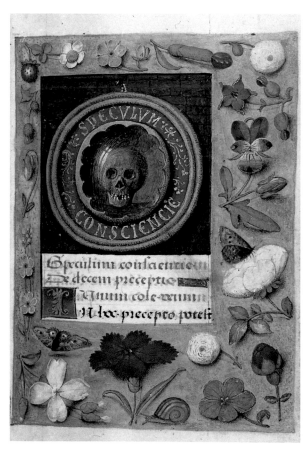

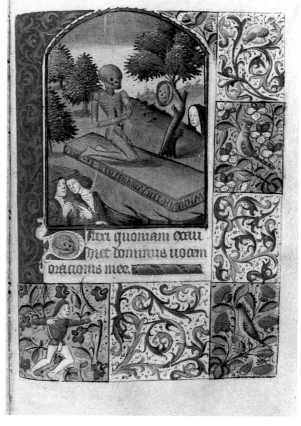

intended for personal use, the kinds of manuscripts I have discussed in this essay functioned, by definition, in the context of an intimate interrelationship between the painted object and its owner.

CONCLUDING COMMENTS

I will not try to summarize the diverse material I have discussed in this essay, but I would like briefly to re-iterate my principal themes. The first is that the aes-thetic creativity of Netherlandish manuscript illumi-nation of the fifteenth and sixteenth centuries is not limited to its splendidly illusionistic paintings, but also encompasses all other aspects of the design of the book, including format, layout, script, and decora-tion. As we have seen, the artisans who created these beautiful objects experimented – and at times played with – all the components of the book, particularly by breaking down the barriers between them. Thus, the shapes of some manuscripts become a kind of image; script sometimes becomes decoration or one of several illusionistically treated elements or fields on the page; and decoration and illustration are intermixed in diverse, even witty fashions.

My second theme is that many of these creative experiments go beyond mere playful aesthetic manipu-lation and express or elaborate meaning in novel and

engaging ways. I have focused in this essay almost exclusively on manuscripts of religious subject matter, for they have different burdens of meaning than works of profane content, and accordingly, they elicited dif-ferent design strategies.[83] Whereas many genres of his-torical or didactic works (chronicles, other histories, romances, some allegorical works), are rooted in worldly realities and follow linear patterns of narrative, works of sacred subject matter, such as Books of Hours and some liturgical books, were intended to guide viewers beyond the here-and-now, to evoke multiple and alternative levels of truth, and to effect profound transformations of understanding. As a consequence, many of the novel juxtapositions of subject matter and scale, of viewpoint and different kinds of illusionism that we have encountered in the works I have discussed were intended to defy customary expectations, contra-vene traditional conventions, and pose contradictions – all in the interest of guiding the users of these books to the leaps of thought and imagination deemed neces-sary to achieve a deepened appreciation of the charac-ter of the sacred and the mysteries of the faith.[84]

And third, I believe that in northern Europe, artists made important new claims concerning the functions and meanings of painted images in manu-scripts, and more specifically, with respect to their immediacy and relevance to their users. The same painters who creatively broke down the barriers

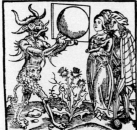
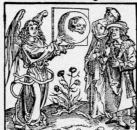

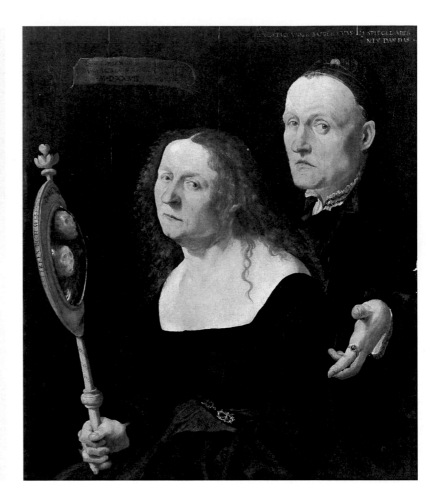

ILL. 72.
"The Devil's and the Angel's Mirrors", single-leaf woodcut (Schreiber 1893d), Germany, ca. 1500 – Stuttgart, Württembergische Landesbibliothek (after P. Heitz, *Primitive Holzschnitte*, Strasbourg, 1913).

ILL. 73.
Laux Furtenagel, *Portrait of the Artist Hans Burgkmair and His Wife Anna*, Augsburg, 1529. – Vienna, Kunsthistorisches Museum, Inv. no. 924.

between the different components of the book eventually addressed the ultimate pictorial barrier, namely, that between the work of art and its beholder. In their works, illusionistic painting becomes a vital means of dissolving the boundaries between art and life, which is to say, that it makes novel demands on viewers' *consciousness* of the nature of works of art and of their relation to them.[85] Many works of flamboyantly illusionistic manuscript illumination should be appreciated not only for their obvious beauty and aesthetic exuberance, but also for their role in addressing issues central to the character and function of the visual arts.

Notes

1. Among recent publications, all with generous bibliographical references, see Blockmans and Prevenier 1986; Blockmans and Prevenier 1999; Belozerskaya 2002.

2. See the survey by Smeyers 1999, and the catalogues of the exhibitions held at Leuven, 2002, St Petersburg-Florence 1996, and most recently, Los Angeles-London 2003.

3. New York, The Pierpont Morgan Library, Ms. M. 6, for which see Wieck 1997: 76-77, no. 58, and http://corsair.morganlibrary.org/msdescr/BBM0006.htm (with full bibliography).

4. Venice, Biblioteca nazionale Marciana, Ms. lat. I, 99. See Salmi and Mellini 1972; Los Angeles-London 2003: 420-424, no. 126.

5. Many of the border motifs on this page, including the peacock and the spilled glass or vase of flowers, reappear in a series of miniatures of other subjects in contemporary Flemish Books of

Hours; they are the subject of a recent lecture, which one hopes will be published, by Challis and Eichberger 2003.

6. New York, The Pierpont Morgan Library, Ms. M. 421, fol. 13v. See Smeyers 1995. Colour reproductions in Wieck 1997: 106-107, no. 82; Smeyers 1999: 263, fig. V, 43

7. Bruges, Groeningemuseum, Inv. no. 0.206. See Friedländer 1967: 69, pl. 63; Dhanens 1980: 293-294 (colour plate) and 389. For derivations from Jan van Eyck's *Rolin Madonna* (Paris, Musée du Louvre, Inv. no. 1271) in French manuscripts of the 1440s and 1450s, see Van Buren 1999.

8. From the *Beatty Rosarium*, possibly made for Emperor Charles V, in Dublin, Chester Beatty Library, Ms. W. 99, fol. 44v. See the facsimile by Testa 1986; Los Angeles-London 2003: 478-480, no. 156. Colour reproduction in Smeyers 1999: 442, fig. VIII, 3.

9. For the likely derivation of the miniature in the *Beatty Rosarium* through the intermediary of a painted copy of Van Eyck's panel by the Master of 1499 (the *Diptych of Chrétien de Hondt* in Antwerp, Koninklijk Museum voor Schone Kunsten, Inv. no. 255), see Testa 1986b. For other sixteenth-century derivatives from this and other panels by Van Eyck, see Mensger 1999.

10. There are few studies of elements of the design of medieval manuscripts. For useful orientation, see the contributions brought together by Martin and Vezin 1990.

11. Paris, Bibliothèque nationale de France, Rothschild Ms. 2973. See Porcher and Droz 1933; Paris 1993: 216-217, no. 119; especially Jager 2000: 83-86. For the broader tradition of unusually shaped manuscripts, including a French royal Book of Hours of the mid-sixteenth century in the shape of a fleur-de-lis, see Vezin 1990.

12. Paris, Bibliothèque nationale de France, Ms. lat. 10536. See Leroquais 1927: vol. 1, 337-338, no. 157, reproduced in Campbell 1998: 148, fig. 1, and Jager 2000: 126-127, fig. 10.

13. London, National Gallery, Inv. no. NG 2612. See Campbell 1998: 346-353 (colour reproduction: 347). The other Portrait of a

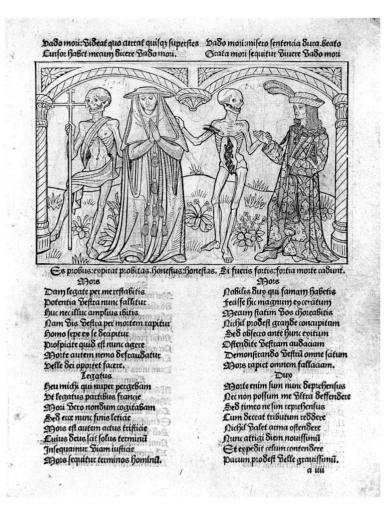

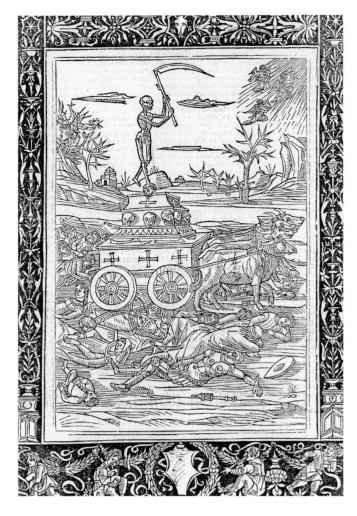

ILL. 74
Death takes a Papal Legate and a Duke, woodcut from the Latin edition of the *Danse Macabre*, Paris, Guy Marchant for Geoffroy de Marnef, 1490. – Washington (DC), Library of Congress, Rosenwald Collection, fol. A4 recto.

ILL. 75.
Triumph of Death, woodcut and metalcut from an edition of Petrarch's *Trionfi*, Milan, Antonius Zarotus, 1494. – Boston, Museum of Fine Arts, Harvey D. Parker Collection.

Man holding a heart-shaped book by the Master of the View of Sainte Gudule is in New York, The Metropolitan Museum of Art, Inv. no. 50.145.27. See New York 1998: 178-181, no. 34 (colour reproduction: 179). For discussions of both, see also Jager 2000: 120-136.

14. From the so-called *Petau Hours* (or "Petau-Rothschild Hours") in Paris, Private Collection, attributed to Jean Poyet of Tours and datable to the last years of the 1490s. See Kraus 1974: 102-105, no. 41 (where attributed to Jean Bourdichon), and for the current attribution to Poyet, see Paris 1993: 307.

15. There is a variant of this scheme in another Book of Hours illustrated by Poyet in Copenhagen, Det Kongelige Bibliothek, Ms. Thott 541, 4°, where the miniatures are lozenge-shaped depictions set into the middle of the leaves commencing major new texts or text segments, and equivalently sized diamond-shaped holes are cut into the intervening text pages. See Wieck, Voelkle and Hearne 2000: 37-39, 189, fig. 32.

16. For Gothic scripts, see the recent book by Derolez 2003.

17. See Bruinsma 1992; Derolez 2003: 157-160.

18. Vienna, Österreichische Nationalbibliothek, Ms. 1857. See Los Angeles-London 2003: 137-141, no. 19; colour facsimiles by Unterkircher and De Schrijver 1969, and Inglis 1995. For additional examples of Spierinc's calligraphically embellished script and further evidence of his activity, see De Schrijver 1969.

19. Waddesdon Manor, James A. de Rothschild Collection, Ms. 8, a copy of the *Epitre* apparently written ca. 1455-1460 for presentation to Philip the Good, but given in an incomplete state to Philip of Cleves, who added his arms and signature and commissioned the extensive cycle of 115 miniatures, which date from around 1485. See Delaissé, Marrow and de Wit 1977: 154-180, where the script and the elaborate pen-work initials are attributed to the workshop of Jean Miélot, a canon of Lille employed from

1449 as secretary of Duke Philip the Good, who translated and wrote books for presentation to the Duke; De Spilener 1990-1991: 70-71, 77-78.

20. From a "Minute", or draft copy, of the *Speculum humanae salvationis* prepared in 1449 for Philip the Good by Jean Miélot of Lille, Brussels, Royal Library of Belgium, Ms. 9249-9250. See Cardon 1996: 230-237, 373-375, figs. 123-127, and *passim*. For other examples of virtually full-page calligraphic letters incorporating figural motifs, see Dumon 1973.

21. For background and orientation on some of the developments I treat here, see the broadly gauged discussion of the formal and structural characteristics of borders and frames in French and Flemish manuscripts of the fifteenth and sixteenth centuries by Orth 1996.

22. From a copy of the Life of St Juliana of Mont-Cornillon (*Vita Sanctae Julianae*) in Paris, Bibliothèque de l'Arsenal, Ms. 945, a Mosan work of ca. 1261-1280. See Lambot 1946 and colour reproduction in Lejeune 1967: pl. 27.

23. Book of Hours, Liège Use, Baltimore, Walters Art Museum, Ms. W. 37. See Randall 1997: 56-64, no. 220, pl. XXVIIIa, figs. 425, 426.

24. Book of Hours, Thérouanne, ca. 1300, in Baltimore, Walters Art Museum, Ms. W. 90. See Randall 1989: 138-142, figs. 112-113, and colour reproduction in Smeyers 1999: 133, fig. III, 32.

25. Book of Hours, Flanders or Artois, ca. 1400-1410, in Baltimore, Walters Art Museum, Ms. W. 215. See Randall 1997: 91-97, no. 227, figs. 437, 438.

26. The *De Lévis Hours*, Paris, ca. 1410-1420, in New Haven, Yale University, Beinecke Library, Ms. 400. See Shailor 1987: 277-280.

27. Book of Hours, Delft, ca. 1415-1420, in New York, The Pierpont Morgan Library, Ms. M. 866. See Utrecht-New York

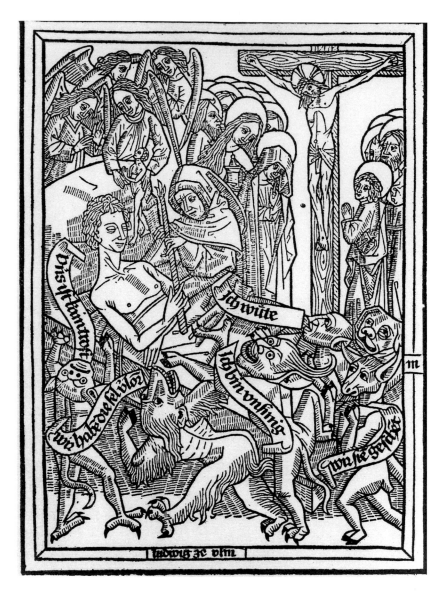

ILL. 76.
Deathbed Scene from a German edition of the *Ars Moriendi* (Schreiber ed. VII A), woodcut by Master Ludwig von Ulm, ca. 1470. – Munich, Bayerische Staatsbibliothek, Xyl. 19, fol. m (after Ernst Weil, intro., *Die deutsche Übersetzung der Ars moriendi des Meisters Ludwig v. Ulm um 1470*, Munich, 1922).

1989: 59-60, no. 12, and colour reproduction in Marrow 2003: fig. 374.

28. Book of Hours, Southern Flanders (probably Ghent), ca. 1450, in Los Angeles, The J. Paul Getty Museum, Ms. 2. See Los Angeles 1985: 200-201, no. 121; Martens 2002; colour reproduction in London 1981: 74; and the Getty's website, http://www.getty.edu/art/collections/objects/01718.html

29. *Hours of Catherine of Cleves*, in New York, The Pierpont Morgan Library, Ms. M. 917. See Utrecht-New York 1989: 152-157, no. 45-46; Plummer 1966: nos. 119 and 112, as well as other margins in this celebrated manuscript.

30. Book of Hours with miniatures by Simon Bening, in Rouen, Bibliothèque Municipale, Ms. 3028 (Leber 142). See As-Vijvers 1999, who includes the Rouen Hours in her discussion of manuscripts with this type of marginal decoration, which contain single painted motives in the borders of all text pages, as well as As-Vijvers 2002 and As-Vijvers 2003; for a facsimile of a Book of Hours with decoration of this type, see Brinkmann and König 1991.

31. See note 30.

32. Krakow, National Museum, Czartoryski Library, Ms. Czart. 3025. See Jarosławiecka-Gąsiorowska 1934: 126-134, pls. XXVII, XVIIa; Brinkmann 1998: 148-153, figs. 35, 48-53; Krakow 2001: 50-51, no. 17. For examples in other manuscripts, including some where painters suggest that floral specimens are affixed to the margins by pins, see Kaufmann and Kaufmann 1991: figs. 13-15, 21; Krieger 1996: 14, fig. 18.

33. For the origins and varieties of panel borders with scatter motifs in *trompe l'oeil*, see Hulin de Loo 1939; Grebe 2001; Nijs 2002, to be supplemented by As-Vijvers 2006 (forthcoming); see Pächt 1948 for what are still the most sensitive comments about the aesthetic implications of the new types of borders.

34. See note 4.

35. Much of this lore was associated by tradition with such classical artists as Zeuxis, Apelles, and Pheideas and was transmitted by such writers as Pliny, Quintillian and Plutarch. For a discussion of this topic focused on early Netherlandish painting, see Preimesberger 1991. Elizabeth Moodey reminds me that this striking example of *trompe l'oeil* on the page with a portrayal of St Luke is the only instance of this kind of illusionism found in the *Grimani Breviary*. See also a small Book of Hours illustrated by Simon Bening and associates in Frankfurt, where a dragonfly is similarly portrayed with transparent wings extending over text, decorated panel borders and part of the outer margin (Frankfurt, Museum für Kunsthandwerk, Ms. LM 56, fol. 17r); significantly, this occurs once again on a page with a miniature of St Luke and it is again the only instance of this kind of bravura *trompe l'oeil* involving text, decorated border and margin in the manuscript in which it appears. See the colour reproduction in Sander 1995: 172, fig. 164, 198, cat. no. 25.

36. Book of Hours, Rome Use, St Benedict (Oregon), Mount Angel Abbey, Ms. 67. See Portland 1978: 36-37, no. 15.

37. New York, The Pierpont Morgan Library, Ms. M. 917. See Utrecht-New York 1989: 152-157, no. 45-46; Plummer 1966: no 118.

38. Madrid, Bibliotheca Nacional, Ms. Vit. 25-5. See Brinkmann 1997: 183-196 and *passim*; Los Angeles-London 2003: 142-146, no. 20. On textile borders, see Nijs 2002: 1022-1023, and for a selection of other examples, Brinkmann 1997: figs. 120, 180, 185, and 186.

39. London, The British Library, Add. Ms. 38126. See Los Angeles-London 2003: 174-176, no. 33, and for comparable examples and variations, Calkins 1989: 5-6, figs 9-11, 13-14.

40. Waddesdon Manor, James A. de Rothschild Collection, Ms. 5. See Delaissé, Marrow and de Wit 1977: 95-105 (where attributed to the Master of Guillebert de Mets), and the re-attribution to the Master of the Privileges of Ghent, Clark 2000: 20-22, 270 and *passim*, figs. 1-10. See also other works where the Master of the Privileges of Ghent depicts tessellation in border foliage (Clark 2000: colour fig. 3, figs. 1, 3, 5, 8, 10, 12-14, 68, 93, 96, 98, 104), in frames of miniatures or baguettes flanking them (Clark 2000: figs. 21, 62, 67, 99, 104, 116) or in large decorated initials (Clark 2000: figs. 52, 64-64, 67, 70, 72, 93, 114, 118, 120, 140, 151, 163, 184).

41. For another example, possibly excised from the same manuscript as the leaves at Waddesdon, see the miniature of St George formerly in the collection of Edouard Kann (Boinet 1926: 13, no. VII, pl. X) and now Paris, Musée Marmottan Monet, Collection Wildenstein, Inv. no. 145 (Musée Marmottan [ca. 1979]: unpaginated, no. 145, ill.).

42. Turin, Museo Civico d'Arte Antica, Inv. no. 47. See Van Buren, Marrow and Pettenati 1994/96.

43. Rouen, Bibliotheque Municipale, Ms. 3028 (Leber 142). See note 30 and Pächt 1983.

44. Bening's depiction echoes exemplars that go back to the Vienna Master of Mary of Burgundy and that circulated in model drawings. See Pächt 1948: pl. 29a and 29b; Pächt 1983: 84-87, figs. 28-30; Los Angeles-London 2003: 146-147, no. 21.

45. From the *Breviary of Eleanor of Portugal*, in New York, The Pierpont Morgan Library, Ms. M. 52. See Los Angeles-London 2003: 321-324, no. 91.

46. Book of Hours, Rome Use, St Benedict (Oregon), Mount Angel Abbey, Ms. 67. See note 36.

47. Los Angeles, The J. Paul Getty Museum, Ms. Ludwig IX 18. See Los Angeles-London 2003: 414-417, no. 124; Calkins 1989: 6, fig. 12.

48. Madrid, Bibliotheca Nacional, Ms. Vit. 25-5. See note 38, and for another example of the text block seemingly tied to the framework of the historiated border in the same manuscript, Los Angeles-London: 142, fig. 20b.

49. Chapeaurouge 1983: 1-61.

50. Venice, Biblioteca nazionale Marciana, Ms. lat. I, 99, for which see note 4. For other examples of the incorporation of texts within images through comparable pictorial conceits, see Calkins 1989: 5-6, figs. 9-14.

51. For background on what follows, see the important comments of Krieger 1996.

52. There is a considerable bibliography of writings about the origins and possible meanings of *trompe l'oeil* marginal decoration in Netherlandish manuscripts of the fifteenth and sixteenth centuries. For a conspectus of different approaches, theories and examples in relatively recent works, see Büttner 1985, Calkins 1989, Steenbock 1990, Kaufmann and Kaufmann 1991, Stoichita 1997: 17-22, Grebe 2001, and the works by As-Vijvers cited above, notes 30 and 33.

53. New York, The Pierpont Morgan Library, Ms. M. 917. See Utrecht-New York 1989: 152-157, no. 45-46; Plummer 1966: no. 123. For another example of a miniature of St Sebastian accompanied by border decoration portraying bows and arrows, from the *Boussu Hours*, a Franco-Flemish work of around 1490, see Martin 1910: 115 (ill.) and 134.

54. Munich, Bayerische Staatsbibliothek, Clm 28345. See Los Angeles-London 2003: 318-321, no. 90, and for this page, the comments of Kaufmann and Kaufmann 1991: 57 and fig. 16, which I echo here.

55. From the *Musgrave Hours* in Upperville, Virgina, Collection of Mrs. Paul Mellon, dated 1524 (formerly Dyson Perrins Collection, Ms. 106). See Warner 1920: 245-249, no. 106, frontispiece and pls. XC-XCI; London 1960: 110-114, lot 144; Testa 1986a: 45-46. For the subject of skulls and other emblems of death in the margins of manuscripts, as well as some of the larger traditions to which they belong, see Büttner 2002: 268-273.

56. Paris, Bibliothèque de l'Arsenal, Ms. 1185. See Martin 1910; Martin and Lauer 1929: 56, pls. LXXVII-LXXVIII; Büttner 1985: 218-226, pl. 23; Legaré 1996: 213-215; Brinkmann 1997: 219, 223; Büttner 2004: 104-112, 127-128, figs. 10-21.

57. As noted by Büttner 1985: 220-221 and Brinkmann 1997: 223, the imagery of the drops of blood in the margins of the text page is further enhanced by the depiction on the same page of a pelican that has pierced its breast to feed its young with its own blood, which was a well-known symbol of Christ's sacrifice.

58. San Marino, The Huntington Library, Ms. HM 1174. See Dutschke and Rouse 1989: 526-528, fig. 143.

59. Lille, Musée des Beaux-Arts, Inv. no. P 832. See Marrow 1979: 84, pl. V; Krebber and Kotting 1990; and for the traditions of the *Fons pietatis* and the *Fons vitae*, Wadell 1969 (the panel in Lille: 49-51, 119, no. 76, pl. 41); Vetter 1972: 293-340 (the panel in Lille: fig. 172).

60. See Charbonneau-Lassay 1940: 619-627.

61. Oxford, Bodleian Library, Ms. Douce 219-220. See Los Angeles-London 2003: 134-137, no. 18; Alexander 1970: pls. 70-71, who observes that the peacock feathers may also allude to the owner of the book, Engelbert of Nassau, whose heraldic crest bore peacock feathers.

62. New York, The Pierpont Morgan Library, Ms. M. 52; Los Angeles-London 2003: 321-324, no. 91.

63. See Challis 1998 (a primarily descriptive study), and for more substantial treatment of the spectrum of allegorical meanings attached to jewels in the Middle Ages, Meier 1977.

64. Oxford, Bodleian Library, Ms. Douce 219-220. See Los Angeles-London 2003: 134-137, no. 18; Alexander 1970: pl. 35.

65. New York, The Pierpont Morgan Library, Ms. M. 399. See Los Angeles-London 2003: 450-451, no. 140.

66. Hildesheim, Dom- und Diözesanmuseum, Inv. no. DS L 109. See Hildesheim 1993: vol. 2, 587-589, cat. no. VIII-34. For comparable jeweled crosses, see Hildesheim 1993: vol. 1: figs. 63, 69, 71; vol. 2: plates pp. 107, 628, and for the tradition of the *crux gemmata*, Lipinsky 1960.

67. Statue-Reliquary of Sainte Foy, Conques, Sainte Foy, Abbey Church. See Paris 1965: 289-294, frontispiece, pls. 34, 35.

68. Golden Pulpit of Henry II, Aachen, Palatine Chapel. See Schramm and Mütherich 1981: 165-166, no. 137, fig. p. 357.

69. Cover of the *Berthold Missal*, in New York, The Pierpont Morgan Library, Ms. M. 710. See Heinzer and Rudolph 1999: 195-204, colour frontispiece, and for the tradition of jewelled bindings, Steenbock 1965.

70. New York, The Pierpont Morgan Library, Ms. M. 917. See Utrecht-New York 1989: 152-157, no. 45-46; Plummer 1966: no. 116. For other examples of depictions of rosaries in the margins of prayer books, see Challis 1998: 261, 263, figs. 71 and 79.

71. Vienna, Österreichisches Nationalbibliothek, Ms. 1857. See Los Angeles-London 2003: 137-141, no. 19, and for this miniature, 126-127, fig. 65. See also Grebe 1999 for the two 'window' frames in this manuscript, and for the possible relationship of the depiction in the Vienna Hours to actual oratories overlooking ecclesiastical interiors, see Belting and Kruse 1994: 56-57, figs. 28-30.

72. London, The British Library, Add. Ms. 18852. See Los Angeles-London 2003: 385-387, no. 114.

73. For the discussion that follows, see the fuller treatment in Marrow 1983.

74. New York, The Pierpont Morgan Library, Ms. M. 796. See Gould 1978: 44-46, and for this figure, Janson 1939-1940: 245, note 7, pl. 37b.

75. Private Collection (USA). See London 1975: 57, lot 90; Versailles 1994: 25, lot 173, colour reproduction on cover; Bartz and König 1987: 513, fig. 13. The kneeling figure represents the deceased rather than Death itself, because the miniature includes a biographical reference in an inscription on the tombstone, which furnishes us with the date of the decedent's burial: *1484. 28. septenbris. fuit. hic. inh(u)m(atus).* For a related version of the same iconography, which lacks, however, any date or other biographical references, see a miniature in a Book of Hours by a Touraine painter of the late fifteenth century formerly in the collection of Major J.R. Abbey, London 1970: 70-71, lot 2888, pl. 36.

76. Schreiber 1926-1930: no.1893d (transcribing the full text that accompanies the woodcut); reproduced by Heitz 1913: pl. 51.

77. Laux Furtenagel, *Portrait of the Artist Hans Burgkmair and His Wife Anna*, 1529, in Vienna, Kunsthistorisches Museum, Inv. no. 924. See Hinz 1974: 167-171.

78. See Rosenfeld 1972, and for the broader topic of death in the Middle Ages, Boase 1972 and Binski 1996.

79. See Van Marle 1932: vol. 2, 367-371; Tenenti 1983: 21-31.

80. See Tenenti 1983: 55-75.

81. From the *Hours of Engelbert of Nassau*, in Oxford, Bodleian Library, Ms. Douce 219-220. See Los Angeles-London 2003: 134-137, no. 18; Alexander 1970: pl. 101, who observes that the inscription on the scroll interlaced among the skulls in the lower margin, *Ce sera moy*, is the motto of the owner of the book, Engelbert of Nassau, and functions here as a *Memento mori*. Significantly, the inscription is in the future tense, which implies that the skulls are not those of Engelbert of Nassau (see also Büttner 2002: 265-268, 270-271, fig. 12).

82. London, National Gallery, Inv. no. NG 186. See Campbell 1998: 174-211; Yiu 2001.

83. See also my fuller comments on aesthetic differences between illustrations in secular and religious manuscripts produced during the late Middle Ages in the Low Countries in a paper that will be included in the proceedings of conferences held in 2004 at the J. Paul Getty Museum and the Courtauld Institute of Art in conjunction with the exhibition *Illuminating the Renaissance: The Triumph of Flemish Manuscript Painting in Europe* (title of the proceedings not yet determined; to be published by the J. Paul Getty Museum in 2006).

84. For related considerations, see Krieger 1996, esp. 14-16.

85. For related notions, particularly in works of seventeenth-century painting, see Stoichita 1997.

ILL. 78.
Jan van Eyck, *Arnolfini Portrait*, oil on panel, Bruges, 1434. – London, National Gallery, Inv. no. NG 186.

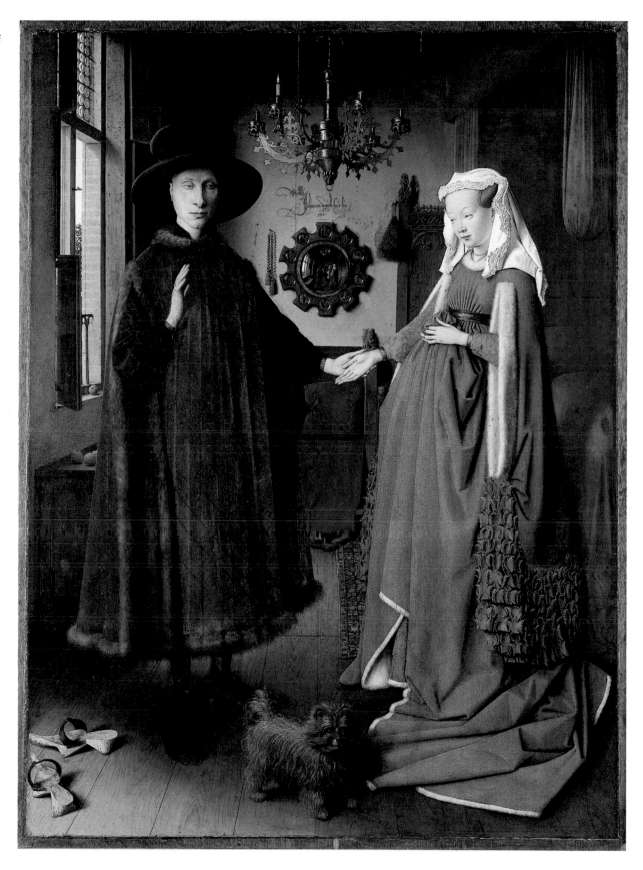

BIBLIOGRAPHY

ALEXANDER 1970

Jonathan J. G. Alexander, *The Master of Mary of Burgundy: A Book of Hours for Engelbert of Nassau. The Bodleian Library, Oxford*, London, 1970.

AS-VIJVERS 1999

Anne Margreet W. As-Vijvers, 'Marginal Decoration in Ghent-Bruges Manuscripts', *Sources for the History of Medieval Books and Libraries*, ed. by Rita Schlusemann, Jos. M.M. Hermans and Margriet Hoogvliet, Boekhistorische Reeks, 2 (ed. by Jos. M.M. Hermans and Christian Coppens), Groningen, 1999: 245-256.

AS-VIJVERS 2002

Anne Margreet W. As-Vijvers, 'Randversiering in Gents-Brugse manuscripten. De Meester van de Davidscènes en andere verluchters als specialisten in marge-decoratie', Ph.D. dissertation, University of Amsterdam, 2002.

AS-VIJVERS 2003

Anne Margreet W. As-Vijvers, 'More than Marginal Meaning? The interpretation of Ghent-Bruges Border Decoration', *Oud Holland* 116 (2003): 3-33.

AS-VIJVERS 2006

Anne Margreet As-Vijvers, *The Making of the Margin: The Master of the David Scenes and Creation by Variation in Ghent-Bruges Manuscript Illumination*, Turnhout, 2006 (forthcoming).

BARTZ AND KÖNIG 1987

Gabriele Bartz and Eberhard König, 'Die Illustration des Totenoffiziums in Stundenbüchern', *Im Angesicht des Todes. Ein interdisziplinäres Kompendium I*, Pietas Liturgica, 3, ed. by Hansjacob Becker, Bernhard Einig and Peter-Otto Ullrich, St. Ottilien, 1987: 487-528.

BELOZERSKAYA 2002

Marina Belozerskaya, *Rethinking the Renaissance: Burgundian Arts across Europe*, Cambridge, 2002.

BELTING AND KRUSE 1994

Hans Belting and Christiane Kruse, *Die Erfindung des Gemäldes: Das erste Jahrhundert der niederländischen Malerei*, Munich, 1994.

BINSKI 1996

Paul Binski, *Medieval Death: Ritual and Representation*, Ithaca (N.Y.), 1996.

BLOCKMANS AND PREVENIER 1986

Wim Blockmans and Walter Prevenier, *The Burgundian Netherlands*, transl. by Peter King and Yvette Mead, Cambridge-New York, 1986.

BLOCKMANS AND PREVENIER 1999

Wim Blockmans and Walter Prevenier, *The Promised Lands: The Low Countries under Burgundian Rule, 1369-1530*, transl. by Elizabeth Fackelman (transl. rev. and ed. by Edward Peters), Philadelphia, 1999.

BOASE 1972

Thomas S.R. Boase, *Death in the Middle Ages: Mortality, Judgment and Remembrance*, London, 1972.

BOINET 1926

Amédée Boinet, *La collection de miniatures de M. Edouard Kann*, Paris, 1926.

BRINKMANN 1997

Bodo Brinkmann, *Die flämische Buchmalerei am Ende des Burgunderreichs: Der Meister des Dresdener Gebetbuchs und die Miniaturisten seiner Zeit*, 2 vols., Ars Nova: Studies in Late Medieval and Renaissance Northern Painting and Illumination, ed. by Maryan W. Ainsworth and Eberhard König, Turnhout, 1997.

BRINKMANN 1998

Bodo Brinkmann, 'Der Maler und sein Kreis', *Das Berliner Stundenbuch der Maria von Burgund und Kaiser Maximilians: Handschrift 78 B 12 im Kupferstichkabinett der Staatlichen Museen zu Berlin Preußischer Kulturbesitz*, exhib. cat. (Berlin, Staatliche

Museen zu Berlin, Preussischer Kulturbestiz, Kupfer-stichkabinett), ed. by Eberhard König with contributions by Fedja Anzelewski, Bodo Brinkmann and Frauke Steenbock, Berlin, 1998: 111-154.

BRINKMANN AND KÖNIG 1991

Bodo Brinkmann and Eberhard König, *Simon Bening. Das Blumen-Stundenbuch / Simon Bening. Le livre d'heures aux fleurs. Clm 23637 Bayerische Staatsbibliothek München*, 2 vols. (facsimile and commentary), Lucerne, 1991.

BRUINSMA 1992

Ernst Bruinsma, 'The lettre bourguignonne in Cambridge University Library Nn.3.2 and other Flemish Manuscripts: A Method of Identification', *Transactions of the Cambridge Bibliographical Society* 10 (1992): 156-164.

BÜTTNER 1985

Frank O. Büttner, 'Ikonographisches Eigengut der Randzier in spätmittelalterlichen Handschriften. Inhalte und Programme', *Scriptorium* 39 (1985): 197-233.

BÜTTNER 2002

Frank O. Büttner, '*Ce sera moy*. Realitätsgehalt und Rhetorik in Darstellungen der Toten- und Vergänglichkeitsikonographie des Stundengebetbuchs', *"Als ich kan". Liber Amicorum in Memory of Professor Dr. Maurits Smeyers*, ed. by Bert Cardon, Jan Van der Stock and Dominique Vanwijnsberghe, Corpus of Illuminated Manuscripts, 11 (Low Countries Series, 8, ed. by Bert Cardon), Paris-Leuven-Dudley (MA), 2002: 243-315.

BÜTTNER 2004

Frank O. Büttner, 'Sehen – versehen – erleben. Besondere Redaktionen narrativer Ikonographie im Stundengebetbuch.' *Images of Cult and Devotion. Function and Reception of Christian Images in Medieval and Post-Medieval Europe*, ed. by Søren Kaspersen, Copenhagen, 2004: 89-148.

CALKINS 1989

Robert G. Calkins, 'Sacred Image and Illusion in Late Flemish Manuscripts', *Essays in Medieval Studies: Proceedings of the Illinois Medieval Association* 6 (1989): 1-29.

CAMPBELL 1998

Lorne Campbell, *National Gallery Catalogues: The Fifteenth Century Netherlandish Schools*, London, 1998.

CARDON 1996

Bert Cardon, *Manuscripts of the Speculum Humanae Salvationis in the Southern Netherlands (c. 1410 – c. 1470). A Contribution to the Study of the 15th Century Book Illumination and of the Function and Meaning of Historical Symbolism*, Corpus of Illuminated Manuscripts, 9 (Low Countries Series, 6, ed. by Maurits Smeyers), Leuven, 1996.

CHALLIS 1998

Kate Challis, 'Marginalized Jewels: The Depiction of Jewellery in the Borders of Flemish Devotional Manuscripts', *The Art of the Book – Its Place in Medieval Worship*, ed. by Margaret M. Manion and Bernard J. Muir, Exeter, 1998: 253-289.

CHALLIS AND EICHBERGER 2003

Kate Challis and Dagmar Eichberger, 'Marginal Decorations, Precious Objects and Private Pursuits', unpublished lecture delivered at the symposium *Illuminating the Renaissance: Burgundian Identities, Flemish Artists and European Markets*, Los Angeles, The J. Paul Getty Museum, September 5-6, 2003.

CHAPEAUROUGE 1983

Donat de Chapeaurouge, *"Das Auge ist ein Herr, das Ohr ein Knecht": der Weg von der mittelalterlichen zur abstrakten Malerei*, Wiesbaden, 1983.

CHARBONNEAU-LASSAY 1940

Louis Charbonneau-Lassay, *Le bestiaire du Christ: la mystérieuse emblématique de Jésus-Christ*, Bruges, 1940.

CLARK 2000

Gregory T. Clark, *Made in Flanders. The Master of the Ghent Privileges and Manuscript Painting in the Southern Netherlands in the Time of Philip the Good*, Ars Nova: Studies in Late Medieval and Renaissance Northern Painting and Illumination, ed. by Maryan W. Ainsworth and Eberhard König, Turnhout, 2000.

DE SCHRIJVER 1969

Antoine De Schrijver, 'Nicolas Spierinc, calligraphe et enlumineur des ordonnances des États de l'Hôtel de Charles le Téméraire', *Scriptorium (Miscellanea F. Lyna)* 23 (1969): 434-458.

DE SPLENTER 1990-1991

Ann De Splenter, 'De rol van Filips van Kleef in de boekverluchting van het laatste kwart van de 15e eeuw', *Gentse bijdragen tot de Kunstgeschiedenis en Oudheidkunde* 29 (1990-1991): 69-90.

DELAISSÉ, MARROW AND DE WIT 1977

Léon M. J. Delaissé, James Marrow and John de Wit, *The James A. de Rothschild Collection at Waddesdon Manor: Illuminated Manuscripts*, London-Fribourg, 1977.

DEROLEZ 2003

Albert Derolez, *The Palaeography of Gothic Manuscript Books: From the Twelfth to the Early Sixteenth Century*, Cambridge Studies in Codicology and Palaeography, 9, Cambridge, 2003.

DHANENS 1980

Elisabeth Dhanens, *Hubert and Jan van Eyck*, Antwerp, 1980.

DUMON 1973
Pierre Dumon, *L'alphabet gothique dit de Marie de Bourgogne: Reproduction du Codex Bruxellensis II 845*, Brussels, 1973.

DUTSCHKE AND ROUSE 1989
Consuelo W. Dutschke and Richard H. Rouse, *Guide to Medieval and Renaissance Manuscripts in the Huntington Library*, 2 vols., San Marino, 1989.

FRIEDLÄNDER 1967
Max J. Friedländer, *Early Netherlandish Painting, I. The van Eycks – Petrus Christus*, transl. by Heinz Norden, Leyden-Brussels, 1967.

GOULD 1978
Karen Gould, *The Psalter and Hours of Yolande of Soissons*, Speculum Anniversary Monographs, 4, Cambridge (Mass.), 1978.

GREBE 1999
Anja Grebe, 'Die Fensterbilder des sogenannten Meisters der Maria von Burgund', *Porträt – Landschaft – Interieur. Jan van Eycks Rolin Madonna im ästhetischen Kontext*, ed. by Christiane Kruse and Felix Thürlemann, Literatur und Anthropologie, 4, Tübingen, 1999: 257-271.

GREBE 2001
Anja Grebe, 'The Art of the Edge: Frames and Page-Design in Manuscripts of the Ghent-Bruges-School', *The Metamorphosis of Marginal Images: From Antiquity to Present Time*, ed. by Nurith Kenaan-Kedar and Asher Ovadiah, Tel Aviv, 2001: 93-102.

HEINZER AND RUDOLPH 1999
Felix Heinzer and Hans Ulrich Rudolph (ed.), *Das Berthold-Sakramentar. Vollständige Faksimile-Ausgabe der Handschrift Ms. M. 710 der Pierpont Morgan Library, New York, Kommentar*, Codices Selecti phototypice impressi, Commentarium Vol. C*, Graz, 1999.

HEITZ 1913
Paul Heitz, *Primitive Holzschnitte. Einzelbilder des XV. Jahrhunderts*, Strassburg, 1913.

HILDESHEIM 1993
Bernward von Hildesheim und das Zeitalter der Ottonen, exhib. cat. (Hildesheim, Dom- und Diözesanmuseum and Roemer- und Pelizaeus-Museum), 2 vols., ed. by Michael Brandt and Arne Eggebrecht, Hildesheim-Mainz, 1993.

HINZ 1974
Berthold Hinz, 'Studien zur Geschichte des Ehepaarbildnisses', *Marburger Jahrbuch für Kunstwissenschaft* 19 (1974): 139-218.

HULIN DE LOO 1939
Georges Hulin de Loo, 'La vignette chez les enlumineurs gantois entre 1470 et 1500', *Académie royale de Belgique. Bulletin de la Classe des Beaux-Arts* 21 (1939): 158-180.

INGLIS 1995
Eric Inglis, *The Hours of Mary of Burgundy. Codex Vindobonensis 1857, Vienna, Österreichische Nationalbibliothek*, London, 1995.

JAGER 2000
Eric Jager, *The Book of the Heart*, Chicago-London, 2000.

JANSON 1939-1940
Horst W. Janson, 'A 'Memento Mori' among early Italian prints', *Journal of the Warburg and Courtauld Institutes* 3 (1939-1940): 243-248.

JAROSŁAWIECKA-GĄSIOROWSKA 1935
Marja Jarosławiecka-Gąsiorowska, 'Les principaux manuscrits à peintures du Musée Czartoryski à Cracovie', *Bulletin de la Société française de reproduction de manuscrits à peintures* 18 (1934), Paris, 1935.

KAUFMANN AND KAUFMANN 1991
Thomas DaCosta Kaufmann and Virginia Roehrig Kaufmann, 'The Sanctification of Nature: Observations on the Origins of Trompe l'oeil in Netherlandish Book Painting of the Fifteenth and Sixteenth Centuries', *The J. Paul Getty Museum Journal* 19 (1991): 43-64.

KRAKOW 2001
Puławska kolekcja rękopisów iluminowanych Księżnej Izabeli Czartoryskiej, exhib. cat. (Muzeum Książąt Czartoryskich), ed. by Barbara Miodońska and Katarzyna Plonka-Bałus, Krakow, 2001.

KRAMER 1971
Joachim Kramer, 'Pfau', *Lexikon der christlichen Ikonographie*, ed. by Engelbert Kirschbaum, vol. 3, Rome-Freiburg-Basel-Vienna, 1971: 409-411.

KRAUS 1974
H.P. Kraus, firm, booksellers, *Monumenta codicum manu scriptorum*, exhib. cat., New York, 1974.

KREBBER AND KOTTING 1990
G.B. Krebber and G. Kotting, 'Jean Bellegambe en zijn *Mysteik Bad* voor Anchin', *Oud Holland*, 104 (1990): 123-139.

KREN AND MCKENDRICK 2003
Thomas Kren and Scot McKendrick, *Illuminating the Renaissance: The Triumph of Flemish Manuscript Painting in Europe*, exhib. cat. (Los Angeles, The J. Paul Getty Museum; London, Royal Academy of Arts), Los Angeles, 2003.

KRIEGER 1996
Michaela Krieger, 'Zum Problem des Illusionismus im 14. und 15. Jahrhundert – ein Deutungsversuch', *Pantheon* 54 (1996): 4-18.

LAMBOT 1946
Cyrille Lambot, 'Un précieux manuscrit de la Vie de Sainte Julienne du Mont-Cornillon,' *Miscellanea historica in honorem Alberti de Meyer*, 1, Université de Louvain, Receuil de Travaux d'Histoire et

de Philologie, 3ième série, 22ième fascicule, Leuven-Brussels, 1946: 603-612 (reprinted in the memorial volume for Lambot, *Revue Bénédictine* 79 [1969]: 223-231).

LEGARÉ 1996
Anne-Marie Legaré, 'L'héritage de Simon Marmion en Hainaut (1490-1520)', *Valenciennes au XIVe et XVe siècles. Art et histoire*, ed. by Ludovic Nys and Alain Salamagne, Valenciennes, 1996: 201-224.

LEJEUNE 1967
Jean Lejeune, *Liège. De la principauté à la métropole*, Antwerp, 1967.

LEROQUAIS 1927
Victor Leroquais, *Les Livres d'heures manuscrits de la Bibliothèque Nationale*, 3 vols., Paris, 1927.

LEUVEN 2002
Medieval Mastery. Book Illumination from Charlemagne to Charles the Bold, 800-1475, exhib. cat. (Leuven, Stedelijk Museum Vander Kelen-Mertens), Leuven, 2002.

LIPINSKY 1960
Angelo Lipinsky, 'La 'Crux gemmata' e il culto della Santa Croce nei monumenti superstiti e nelle raffigurazioni monumentali', *Felix Ravenna* 81/82 (1960): 5-53.

LONDON 1960
London, Sotheby's, 29-11-1960: *The Dyson Perrins Collection, Part III* (auct. cat.).

LONDON 1970
London, Sotheby's, 01-12-1970: *Catalogue of The Celebrated Library The Property of The Late Major J. R. Abbey Sold by Order of the Executors, The Seventh Portion* (auct. cat.).

LONDON 1975
London, Sotheby's, 08-12-1975: *Catalogue of Western Manuscripts and Miniatures* (auct. cat.).

LONDON 1981
London, Sotheby's, 18-05-1981: *Western Illuminated Manuscripts the Property of The John Carter Brown Library, Providence, Rhode Island* (auct. cat.).

MARROW 1979
James H. Marrow, *Passion Iconography in Northern European Art of the Late Middle Ages and Early Renaissance*, Ars Neerlandica, 1, Kortrijk, 1979.

MARROW 1983
James H. Marrow, '*In desen speigell*: A New Form of *Memento Mori* in Fifteenth Century Netherlandish Art', *Essays in Northern European Art Presented to Egbert Haverkamp Begemann*, ed. by Anne Marie Logan *et al.*, Doornspijk, 1983: 154-163.

MARROW 2003
James H. Marrow, 'L'enluminure dans les Pays-Bas septentrionaux', *L'art flamand et hollandais: Le siè-cle des Primitifs 1380-1520*, sous la direction de Christian Heck, Paris, 2003: 297-329.

MARTENS 2002
Maximilian P.J. Martens, 'The Master of Guillebert de Mets: An Illuminator between Paris and Ghent?', *"Als ich kan". Liber Amicorum in Memory of Professor Dr. Maurits Smeyers*, ed. by Bert Cardon, Jan Van der Stock and Dominique Vanwijnsberghe, Corpus of Illuminated Manuscripts, 12 (Low Countries Series, 9, ed. by Bert Cardon), Paris-Leuven-Dudley (MA), 2002: 921-939.

MARTIN 1910
Henry Martin, 'Les 'Heures de Boussu' et leurs bordures symboliques', *Gazette des Beaux-Arts* 52 (1910): 115-138.

MARTIN AND LAUER 1929
Henry Martin and Philippe Lauer, *Les principaux manuscrits à peintures de la Bibliothèque de l'Arsenal à Paris*, Paris, 1929.

MARTIN AND VEZIN 1990
Henri-Jean Martin and Jean Vezin (eds.), *Mise en page et mise en texte du livre manuscrit*, s.l. [Paris], 1990.

MEIER 1977
Christel Meier, *Gemma spiritalis: Methode und Gebrauch der Edelsteinallegorese vom frühen Christentum bis ins 18. Jahrhundert*, Teil I [all published], Münstersche Mittelalter-Schriften, Band 34.1, Munich, 1977.

MENSGER 1999
Ariane Mensger, 'Blick zurück nach vorn – Jan Gossaert kopiert Jan van Eyck', *Porträt – Landschaft – Interieur. Jan van Eycks Rolin Madonna im ästhetischen Kontext*, ed. by Christiane Kruse and Felix Thürlemann, Literatur und Anthropologie, 4, Tübingen, 1999: 273-290.

MUSÉE MARMOTTAN [CA. 1979]
Académie des Beaux-Arts. *La collection Wildenstein*, intro. Yves Brayer, Paris, s.d. [ca. 1979].

NEW YORK 1998
From Van Eyck to Bruegel: Early Netherlandish Painting in The Metropolitan Museum of Art, exhib. cat. (New York, Metropolitan Museum of Art), ed. by Maryan W. Ainsworth and Keith Christiansen, New York, 1998.

NIJS 2002
Greet Nijs, 'Typology of the Border Decoration in the Manuscripts of the Ghent-Bruges School', *"Als ich kan". Liber Amicorum in Memory of Professor Dr. Maurits Smeyers*, ed. by Bert Cardon, Jan Van der Stock and Dominique Vanwijnsberghe, 2, Corpus of Illuminated Manuscripts, 12 (Low

Countries Series, 9, ed. by Bert Cardon), Paris-Leuven-Dudley (MA), 2002: 1007-1036.

ORTH 1996

Myra D. Orth, 'What Goes Around: Borders and Frames in French Manuscripts', *Journal of the Walters Art Gallery. Essays in Honor of Lilian M.C. Randall* 54 (1996): 189-201.

PÄCHT 1948

Otto Pächt, *The Master of Mary of Burgundy*, London, 1948.

PÄCHT 1983

Otto Pächt, 'Die Evangelistenbilder in Simon Benings Stockholmer Stundenbuch (Kgl. Bibliothek, A 227)', *Nationalmuseum Bulletin* 7 (1983): 71-92.

PARIS 1965

Les Trésors de eglises de France, exhib. cat. (Paris, Musée des Arts Decoratifs), Paris, 1965.

PARIS 1993

François Avril and Nicole Reynaud, *Les manuscrits à peintures en France 1440-1520*, exhib. cat. (Paris, Bibliothèque nationale de France), Paris, 1993.

PLUMMER 1966

John Plummer, *The Hours of Catherine of Cleves*, New York, 1966.

PORCHER AND DROZ 1933

Jean Porcher and Eugénie Droz, 'Le Chansonnier de Jean de Montchenu', *Trésors des bibliothèques de France* 5 [fasc. 18] (1933): 100-110, pl. XXX-XXXIII.

PORTLAND 1978

Illuminated Manuscripts from Portland Area Collections, exhib. cat. (Portland Art Museum), ed. by Peter W. Parshall, Portland, 1978.

PREIMESBERGER 1991

Rudolf Preimesberger, 'Zu Jan van Eyck's Diptychon der Sammlung Thyssen-Bornemisza', *Zeitschrift für Kunstgeschichte* 54 (1991): 459-489.

RANDALL 1989

Lilian M.C. Randall, *Medieval and Renaissance Manuscripts in the Walters Art Gallery, Volume I: France, 875-1420*, Baltimore-London, 1989.

RANDALL 1997

Lilian M.C. Randall, *Medieval and Renaissance Manuscripts in the Walters Arts Gallery, Volume III: Belgium, 1250-1530*, Parts 1-2, Baltimore-London, 1997.

RINGBOM 1984

Sixten Ringbom, *Icon to Narrative: The Rise of the Dramatic Close-up in Fifteenth-Century Devotional Painting*, 2nd ed., Doornspijk, 1984.

ROSENFELD 1971

Helmut Rosenfeld, 'Totentanz', *Lexikon der christlichen Ikonographie*, ed. by Engelbert Kirsch-

baum, 4, Rome-Freiburg-Basel-Vienna, 1972: 343-347.

ST PETERSBURG-FLORENCE 1996

Flemish Illuminated Manuscripts, 1475-1550, exhib. cat. (St Petersburg, State Hermitage Museum; Florence, Museo Bardolino), ed. by Maurits Smeyers and Jan Van der Stock, Ghent-New York, 1996.

SANDER 1995

Jochen Sander, 'Die Entdeckung der Kunst': Niederländische Kunst des 15. und 16. Jahrhunderts in Frankfurt, exhib. cat. (Frankfurt am Main, Städelsches Kunstinstitut und Städtische Galerie), Mainz, 1995.

SALMI AND MELLINI 1972

Mario Salmi and Gian Lorenzo Mellini, *The Grimani Breviary, Reproduced from the Illuminated Manuscript belonging to the Biblioteca Marciana, Venice*, London, 1972.

SCHRAMM AND MÜTHERICH 1981

Percy Ernst Schramm and Florentine Mütherich, *Denkmale der deutschen Könige und Kaiser*, 2nd ed., Veröffentlichungen des Zentralinstituts für Kunstgeschichte in München, 2.1, Munich, 1981.

SCHREIBER 1926-1930

Wilhelm L. Schreiber, *Handbuch der Holz- und Metallschnitte des XV. Jahrhunderts*, 8 vols., Leipzig, 1926-1930.

SHAILOR 1987

Barbara A. Shailor, *Catalogue of Medieval and Renaissance Manuscripts in the Beinecke Rare Book and Manuscript Library, Yale University, Volume II: MSS 251-500*, Medieval and Renaissance Texts and Studies, 48, Binghamton, 1987.

SMEYERS 1995

Maurits Smeyers, 'An Eyckian Vera Icon in a Bruges Book of Hours, ca. 1450 (New York, Pierpont Morgan Library, Ms. 421)', *Serta devota in memoriam Guillelmi Lourdaux, Pars Posterior: Cultura mediaevalis*, ed. by Werner Verbeke, Marcel Haverals, Rafaël De Keyser and Jean Goossens, Leuven, 1995: 195-224.

SMEYERS 1999

Maurits Smeyers, *Flemish Miniatures from the 8th to the mid-16th Century: The Medieval World of Parchment*, transl. by Karen Bowen and Dirk Imhoff, Leuven, 1999.

STEENBOCK 1965

Frauke Steenbock, *Der Kirchliche Prachteinband im frühen Mittelalter von den Anfängen bis zum beginn der Gotik*, Berlin, 1965.

STEENBOCK 1990

Frauke Steenbock, '"Largesse" – Münzen, Blüten und Mannaregen: Eine Motivstudie', *Festschrift für Peter Bloch zum 11. Juli 1990*, ed. by Hartmut

Krohm and Christian Theuerkauf, Mainz, 1990: 135-142.

STOICHITA 1997
Victor I. Stoichita, *The Self-Aware Image: An Insight into Early Modern Meta-Painting*, transl. by Anne-Marie Glasheen, Cambridge Studies in New Art History and Criticism, Cambridge, 1997.

TENENTI 1983
Alberto Tenenti, *La vie et la mort à travers l'art du XVe siècle*, 2nd ed., s.l., 1983.

TESTA 1986A
Judith Anne Testa, *The Beatty Rosarium: A Manuscript with Miniatures by Simon Bening*, Studies and Facsimiles of Netherlandish Illuminated Manuscripts, 1, Doornspijk, 1986.

TESTA 1986B
Judith Anne Testa, 'A Note on the Relationship of Manuscript Illumination and Panel Painting: Simon Bening's Beatty Rosarium and the Diptych of Chrétien de Hondt', *Jaarboek Koninklijk Museum voor Schone Kunsten Antwerpen*, 1986: 19-29.

THE J. PAUL GETTY MUSEUM 1985
The J. Paul Getty Museum, 'Acquisitions 1984: Manuscripts', *The J. Paul Getty Museum Journal* 13 (1985): 199-204.

UNTERKIRCHER AND DE SCHRIJVER 1969
Franz Unterkircher and Antoine de Schrijver, *Gebetbuch Karls des Kühnen vel potius, Stundenbuch der Maria von Burgund: Codex Vindobonensis 1857 der Österreichischen Nationalbibliothek*, 2 vols., Codices selecti, 14, Graz, 1969.

UTRECHT-NEW YORK 1989
The Golden Age of Dutch Manuscript Painting, exhib. cat. (Utrecht, Rijksmuseum Het Catharijneconvent; New York, The Pierpont Morgan Library), Stuttgart-New York, 1989.

VAN BUREN 1999
Anne H. van Buren, 'Die Rezeption der Rolin-Madonna durch die Zeitgenossen Jan van Eycks – Eine Rekonstruktion auf der Grundlage von Texten und Bildkopien', *Porträt – Landschaft – Interieur. Jan van Eycks Rolin Madonna im ästhetischen Kontext*, ed. by Christiane Kruse and Felix Thürlemann, Literatur und Anthropologie, 4, Tübingen, 1999: 147-164.

VAN BUREN, MARROW AND PETTENATI 1994/96
Anne H. van Buren, James H. Marrow and Silvana Pettenati, *Heures de Turin-Milan, Inv. No. 47, Museo Civico d'Arte Antica, Torino*, 2 vols., Lucerne 1994 (facsimile) and 1996 (commentary).

VAN MARLE 1932
Raimond Van Marle, *Iconographie de l'art profane au Moyen-Age et à la Renaissance*, 2 vols., The Hague, 1932.

VERSAILLES 1994
Vente aux encheres publiques, auct. cat., sale at Galerie des Chevau-Légers, Versailles, March 13, 1994.

VEZIN 1990
Jean Vezin, 'Formes insolites', *Mise en page et mise en texte du livre manuscrit*, ed. by Henri-Jean Martin and Jean Vezin, s.l. [Paris], 1990: 456-458.

WADELL 1969
Maj-Brit Wadell, *Fons Pietatis. Eine Ikonographische Studie*, Göteborg, 1969.

WARNER 1920
George Warner, *Descriptive Catalogue of Illuminated Manuscripts in the Library of C.W. Dyson Perrins*, 2 vols., Oxford, 1920.

WIECK 1997
Roger S. Wieck, *Painted Prayers: The Book of Hours in Medieval and Renaissance Art*, New York, 1997.

WIECK, VOELKLE AND HEARNE 2000
Roger S. Wieck, William M. Voelkle, and K. Michelle Hearne, *The Hours of Henry VIII: A Renaissance Masterpiece by Jean Poyet*, New York, 2000.

YIU 2001
Yvonne Yiu, *Jan van Eyck. Das Arnolfini-Doppelbildnis: Reflexionen über die Malerei*, Nexus 51, Frankfurt am Main-Basel, 2001.

LIST OF ILLUSTRATIONS

Demeure Hours, Ghent, ca. 1475-1480. – Madrid, Bibliotheca Nacional, Ms. Vit. 25-5, fol. 187.

ILL. 37.
Text leaf with 'fabric' border, from the *Huth Hours*, Bruges, ca. 1480-1485. – London, The British Library, Add. Ms. 38126, fol. 241.

ILL. 38.
Master of the Privileges of Ghent, *Nativity*, detached miniature from a Book of Hours, Tournai (?), ca. 1440-1450. – Waddesdon Manor, James A. de Rothschild Collection, Ms. 5, fol. 3.

ILL. 39.
Master of the Privileges of Ghent, *Massacre of the Innocents*, detached miniature from a Book of Hours, Tournai (?), ca. 1440-1450. – Waddesdon Manor, James A. de Rothschild Collection, Ms. 5, fol. 8.

ILL. 40.
"Hand G" (Jan van Eyck?), *The Birth of St John the Baptist* (large miniature) and *Baptism of Christ* (historiated initial and bas-de-page), leaf from the *Turin-Milan Hours*, The Hague (?), ca. 1425. – Turin, Museo Civico d'Arte Antica, Inv. no. 47, fol. 93v.

ILL. 41.
Simon Bening, *Visitation*, miniature from a Book of Hours, Bruges, ca. 1520-1530. – Rouen, Bibliothèque Municipale, Ms. 3028 (Leber 142), fol. 105.

ILL. 42.
Simon Bening, *Nativity* (central miniature) and *Mary and Joseph refused Admittance to the Inn at Bethlehem* (historiated border), miniature from a Book of Hours, Bruges, ca. 1520-1530. – Rouen, Bibliothèque Municipale, Ms. 3028 (Leber 142), fol. 116.

ILL. 43.
Scenes from the Life of St Anthony, miniature from the *Breviary of Eleanor of Portugal*, Ghent, ca. 1500-1510. – New York, The Pierpont Morgan Library, Ms. M. 52, fol. 412.

ILL. 44.
Crucifixion, miniature from a Book of Hours, Bruges, ca. 1490. – St Benedict (Oregon), Mount Angel Abbey, Ms. 67, fol. 8.

ILL. 45.
Master of James IV of Scotland, *The Trinity*, miniature from the *Spinola Hours*, Bruges and Ghent, ca. 1510-1520. – Los Angeles, The J. Paul Getty Museum, Ms. Ludwig IX 18, fol. 100v.

ILL. 46.
Vienna Master of Mary of Burgundy, *Scenes from the Passion*, miniature from the *Voustre Demeure Hours*, Ghent, ca. 1475-1480. – Madrid, Bibliotheca Nacional, Ms. Vit. 25-5, fol. 14.

ILL. 47.
Master of James IV of Scotland, *Building of the Tower of Babel*, miniature from the *Grimani Breviary*, Ghent and Bruges, ca. 1515-1520. – Venice, Biblioteca nazionale Marciana, Ms. lat. I, 99, fol. 206.

ILL. 48.
Saints Fabian and Sebastian, miniature from the *Hours of Catherine of Cleves*, Utrecht, ca. 1440. – New York, The Pierpont Morgan Library, Ms. M. 917, p. 253.

ILL. 49.
Suffrage of St James with border of cockle shells, miniature from a Book of Hours, Bruges, ca. 1495-1500. – Munich, Bayerische Staatsbibliothek, Clm. 28345, fol. 265.

ILL. 50.
Simon Bening, *Funeral Service and border of skulls*, leaf from the *Musgrave Hours*, Bruges, 1524. – Upperville, Virginia, Collection Mrs. Paul Mellon, s.n., fol. 265v.

ILL. 51.
Master of Antoine Rolin, *Agony in the Garden of Gethsemane*, miniature from the *Boussu Hours*, Hainaut, ca. 1490. – Paris, Bibliothèque de l'Arsenal, Ms. 1185, fol. 186v.

ILL. 52.
Master of Antoine Rolin, *Christ before Pilate and border with drops of blood and tears*, miniature from the *Boussu Hours*, Hainaut, ca. 1490. – Paris, Bibliothèque de l'Arsenal, Ms. 1185, fol. 187.

ILL. 53.
Master of Antoine Rolin, *Carrying of the Cross*, miniature from the *Boussu Hours*, Hainaut, ca. 1490. – Paris, Bibliothèque de l'Arsenal, Ms. 1185, fol. 195v.

ILL. 54.
Master of Antoine Rolin, *Christ Nailed to the Cross and border of crying eyes*, miniature from the *Boussu Hours*, Hainaut, ca. 1490. – Paris, Bibliothèque de l'Arsenal, Ms. 1185, fol. 196.

(DC), Library of Congress, Rosenwald Collection, fol. A4 recto.

ILL. 75.

Triumph of Death, woodcut and metalcut from an edition of Petrarch's *Trionfi*, Milan, Antonius Zarotus, 1494. – Boston, Museum of Fine Arts, Harvey D. Parker Collection.

ILL. 76.

Deathbed Scene from a German edition of the *Ars Moriendi* (Schreiber ed. VII A), woodcut by Master Ludwig von Ulm, ca. 1470. – Munich, Bayerische

Staatsbibliothek, Xyl. 19, fol. m (after Ernst Weil, intro., *Die deutsche Übersetzung der Ars moriendi des Meisters Ludwig v. Ulm um 1470*, Munich, 1922).

ILL. 77.

Vienna Master of Mary of Burgundy, *Burial of a Corpse with border of Skulls*, miniature from the *Hours of Engelbert of Nassau*, Ghent, ca. 1475-1485. – Oxford, Bodleian Library, Ms. Douce 219-220, fol. 214.

ILL. 78.

Jan van Eyck, *Arnolfini Portrait*, oil on panel, Bruges, 1434. – London, National Gallery, Inv. no. NG 186.

PHOTO CREDITS

INDEX OF MANUSCRIPTS AND OTHER WORKS OF ART

PRINTED ON PERMANENT PAPER • IMPRIME SUR PAPIER PERMANENT • GEDRUKT OP DUURZAAM PAPIER - ISO 9706

N.V. PEETERS S.A., WAROTSTRAAT 50, B-3020 HERENT